Da xiang art space

藝拓荒原→東方八大響馬
Exploring the Wasteland – *The Eight Highwaymen of the East*

策展人/劉永仁
Curator/ Liú Yung-Jen

目　次
Contents

馳騁中國現代藝術荒野的開拓者

大象藝術空間館 藝術總監 鍾經新

那些人，那些畫，還有自由孤寂

這些年，還記得李仲生安東街畫室嗎？畫室的情境是既模糊又清晰，模糊的是建物已掩入歷史，清晰的是記憶再度被喚起。「以思想作為基礎，藝術才具備永恆性」的教學精神，深深啟迪這一群用生命韌性換來藝術視野的開拓者。「開拓者」在以前專用來稱呼那些發現未知土地或是在未知土地上生活的人，也常常指那些在未知的領域作出突出貢獻的人。

以李仲生為精神導師的一群大陸來台藝術家，於1956年成立東方畫會，視現代抽象為目標，冀望傳達前衛理念，表達個人多元的繪畫面目；創始成員包括李元佳、歐陽文苑、吳昊、霍剛、夏陽、陳道明、蕭勤、蕭明賢等八位，因何凡的一句戲稱，卻凝聚了「八大響馬」在藝術荒野的馳騁，他們試圖以更自由的創作態度與中國文化結合，開創屬於六〇年代的現代中國繪畫。

「八大響馬」於藝術創作歷程期間，雖習於李仲生老師，但在孤寂驅使的環境中，自由心靈的深層掙扎，讓同個平面軸點展現出各自的原貌觀點，延續似桀傲不遜卻理性的脈絡紋理，蘊育內涵也萃煉無限勇氣，以不同形式、不同手法，或者不同介面來詮釋自己內心的吶喊。每每當欣賞這些畫作時，心中感動氛圍佇立許久，欣慰能量尚未消失，生命軌跡一直存續著。

大象藝術空間館深感歷史印跡的珍貴與不可再復，並對東方八大響馬開創精神的特別推崇！特邀對東方畫會的歷史典故熟稔深入的策展人劉永仁先生，來規劃此一歷史性的展覽，從談起此構想意念直到展覽執行，歷時年餘；期間獲得多位資深藏家與藝術家的大力相挺，有王飛雄先生、朱為白先生、林學熙先生、孫巍先生及陳明仁先生，因為對大象藝術此次活動的肯定與信任，他們把最珍貴的早年收藏大方的借與大象展覽，甚且遠從義大利專程送回展品，此情此義唯有敦促自己努力將展覽活動辦成功以為報。另外，藝術家蕭明賢先生也熱情地特別從美國寄送作品至大象，還有霍剛及朱為白二位老師也提供了相當珍貴的歷史資料，讓此次的歷史性梳理能有一個完整的呈現，透過策展人劉永仁先生的睿智及積極奔走，才能讓那些曾經活躍的美好年代，在這一刻開啟了瞬間的永恆。

遙望著東方畫會的瑰麗歷史，很慶幸能在大象藝術又重新再現！
感謝過程當中曾給予協助的所有朋友們！因為您們的大愛，才能展現成功的果實！

Pioneers in the Territory of Chinese Modern Art

Chung Ching Hsin, Director of Da Xiang Art Space

–Those People, Those Pictures, and the Freedom of Solitude

Do you still remember Li Chuhshan's studio on Andong Street back in those days? The image of the studio is not only vague but clear. It's vague because the building is no longer there. And the image can become clearer when our memory is aroused. With the philosophy that "only when mind is your foundation will your art be eternal," Li has deeply inspired many young artists, some of whom later became the toughest pioneers in the artistic territory. *We used to call those who find unknown lands or live on unexplored territories "pioneers". However, this term can be also referred to people who have made outstanding contributions in untracked areas.*

And Ton Fon Art Group is one of the best examples. It was founded in 1956 by a group of artists who had been originally from mainland China and had seen of Li Chuhshan as their mentor. They advocated modern abstractionism as their ultimate goal, trying to advance avant-garde and to express their personal diversity in creation. The group founders include Li Yuan-chia, Oyan Wenyung, Wu Hao, Ho Kan, Hsia Yan, Chen Taoming, Hsiao Chin and Hsiao Ming-hsien. They are also known as "the Eight Highwaymen," due to a bantering remark by writer He Fan, because they are like chivalry pioneering in the territory of art. They have been pursuing freer style of creation but have never discarded Chinese culture, and have thus created a golden age of modern Chinese painting in the 1960s.

Although "the Eight Highwaymen" were all ex-students of Li Chuhshan, they have respectively developed different styles as well as diverse skills, and each has their preferred media to describe their emotional states. In other words, they each have their own struggles deep in their heart while facing the environment of loneliness, but they defiantly and rationally choose unique media to manifest their own point of view with amazing courage. Therefore, every time when I watch their paintings, I feel so touched for a long time. Standing in front of their paintings, I am glad to find the energy still lingering and the vigor remaining.

Da Xiang Art Space has been cherishing the history and realizes that it is not an easy task to restore the past. Since we have been long highly praising "the Eight Highwaymen" on pioneering in modern art, we have invited senior curator Liú Yung-Jen, who has an extensive understanding of Ton Fon Art Group, to organize this historic exhibition. It has taken us more than one year to organize this exhibition. And we are thankful for many experienced collectors as well as artists and their support, including Wang Fei-shiung, Chu Weibor, Lin Shieh-shi, Franco Sun and Chen Ming-jen. Due to their faith in Da Xiang Art Space, they generously lent us their most precious collection from early years, some of which were even shipped from as far away as Italy exclusively for this exhibition. We feel such an immense gratitude to them that we have hardly anything to give in return but to exert the most effort to make the exhibition a success. Also, we are thankful for Hsiao Minghsien for having enthusiastically shipped his artworks to us from the USA. And thanks to the valuable historical information provided by Ho Kan and Chu Weibor, we can have a more comprehensive exhibition. Once again, we'd like to thank curator Liú Yung-Jen. Without his wisdom and aggressiveness, the

golden age in the past cannot be recaptured in this exhibition, nor can viewers witness the beauty of the eternity.

Furthermore, we are not only glad but proud to see that the magnificent history of Ton Fon Art Group is reproduced here in Da Xiang Art Space. As for those who have given us assistance, we cannot be more grateful. And it is because of your unselfish sharing that this exhibition can be so fruitful and successful.

藝拓荒原→東方八大響馬

策展人／ 劉永仁

六〇年代台灣現代藝術環境，正如當時台北東區一片野曠，年輕藝術家的創作欲望，渴望突破體制規範，自由馳騁表達，在當時的社會氣氛，「自由」就是一種危險，而自由創作之後，能公開展示更需要勇氣，一切的藝術氛圍，可以說保守而貧瘠，如同荒原一般的狀態，但一批年輕藝術家，已用生命的野性，衝撞體制與觀念，在現在看來，宛如史詩般瑰麗雄渾，開拓荒原的意義更為肯定。

1956年11月，台灣現代藝術團體「東方畫會」成立，創始核心成員：李元佳、歐陽文苑、吳昊、霍剛、夏陽、蕭勤、陳道明、蕭明賢，他們有自由創新的信念，並以旺盛的鬥志和勇往直前的衝勁致力於藝術創作，人稱「八大響馬」。1957年11月5、6日兩天，作家何凡於東方畫會首展前，在聯合副刊專欄「玻璃墊上」以〈「響馬」畫展〉為題，為大眾報導介紹東方畫會。「響馬」一詞，為大陸北方稱呼強盜的別稱，他們在行動前習慣先放響箭以示警，何凡以戲謔之口吻，將東方畫會八位創始者稱之為「八大響馬」，形容其闖蕩叛逆的性格，於是半世紀以來，八大響馬已成為東方畫會的別稱。

近年來，關於研究探討書寫「東方畫會」的文獻資料愈來愈豐富，然而，策辦以東方八大響馬的展覽卻並不多見，在策展過程中，洽借八位藝術家的早期作品是比較有難度與挑戰性，除了向藝術家本人、藝術家友人和台灣的收藏家商借作品之外，甚至於向遠在義大利的收藏家借得蕭勤與霍剛早期的作品，幸賴他們慷慨鼎力相助，使得八位藝術家的作品得以齊集完整呈現。本展側重再現八位藝術家的原創性與鮮明特色，雖同屬一畫會，但每個人思考方式截然不同，尤其在保守的戰後島嶼上，他們的思想與作品，為現代藝術拓荒，也為人們慣性僵化的視覺心靈，啟開另一扇藝術視窗。

觀念變革中的繪畫

台灣現代藝術搖籃，回溯李仲生安東街畫室，他以啟發式的教學與創作觀念深深影響東方八大響馬日後藝術生涯之開展。現代藝術思想的啟蒙者李仲生的教學方式，著重腦、眼、心、手配合的觀念，強調以線性素描入手，所謂"心象素描"，即試圖挖掘內心真實的潛能，透過心理學來瞭解學生的個性與資質，激發創造力，並以思想傳精神，唯有創作態度，既是思想的活力，亦為生命的活力，祇有以思想作為基礎，藝術才結實注入了永恆的生命。值得關注的是，東方八大響馬受教於李仲生，並不因襲李氏風貌，而卻能各自開拓一片視野，繪畫面目之豐富多元，在當時實為難得。

東方畫會之精神

「東方畫會」名稱之由來，最初畫會提議之名稱包括：「一九五七年畫會」、「純粹畫會」、「安東畫會」，但最終以霍剛提議的「東方畫會」為名，主要寓意：一、太陽自東方升起，有朝氣活力，象徵藝術新生的力量。二、畫友都生長在東方，而且多數創作都著重在東方精神的表現。註1 **「東方畫會」首屆展覽的展覽目錄**，由夏陽起草擬訂「我們的話」，作

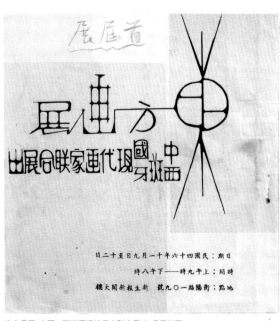

東方畫展-中國、西班牙現代畫家聯合展出_畫冊封面
Oriental Paintings Exhibition- A catalog cover of a joint exhibition by Chinese and Spanish modern painters

為畫會開展宣言，這是一篇開拓理想願景的文字，致力於引進藝術新思潮：『……二十世紀的一切早已嚴重地影響著我們，我們必須進入到今日的時代環境裏，趕上今日的世界潮流，隨時吸收新的觀念，然後才能發展創造，就藝術方面而言，如果僅是固守舊有的形式，實為窒息了中國藝術的生長，不但使傳統的精神永遠無從發揮，並且反而造成了日趨沒落底必然情勢。……』同時強調中國傳統精神的價值：『……我國傳統的繪畫觀，與現代世界性的繪畫觀在根本上完全一致，惟於表現的形式上稍有差異，如能使現代繪畫在我國普遍發展，則中國的無限藝術寶藏，必將在今日世界潮流中以嶄新的姿態出現，……』其藝術主張述及自由心靈的可貴：『……真正的藝術決不是所謂象牙塔中的產品，也決不是自我陶醉的工具，而是給大家欣賞的，但是我們反對共產集團的藝術大眾化底謬論，因為如此正是減少了人們美感的多樣需要，縮小了人們美感的範圍，這不啻為一種心靈底壓迫，我們認為大眾藝術化是對的，一方面儘量提倡以養成風氣，另一方面將各種各樣的藝術放在人們的眼前，這樣才能使人們的視野到了自由，而使心靈的享受擴展無限。……』註2

進駐防空洞切磋畫藝

藝術家創作需要空間思考、揮筆，工作室即是畫家思考蘊育作品的場所。1952年，吳昊與歐陽文苑、夏陽先行進駐防空洞作畫，以防空洞作為畫室以及談藝論道的據點，可視為早期閒置空間再利用的典型範例。當時的防空洞位於龍江街，是日本人留下來的一間水泥平頂式的建築物，水泥牆厚實，只有兩個門，沒有窗戶，也許準備放重要的東西，以防轟炸，防空洞為軍官管理做為附近眷屬疏散之用，平時是空著的，當時吳昊和歐陽文苑、夏陽三人都在空軍服務，每天下班後、星期假日，都在防空洞畫畫，當時吳昊是空軍少尉，負責保管防空洞。防空洞約有四十幾坪，夜間裝上電燈，晚上也可以作畫，以防空洞作為畫室，他們三人各據一空間創作並不相互干擾，平時也有很多畫友來這裡聚集，聖誕節也組織活動如開舞會。時常來走訪的畫家如：席德進、顧福生、劉國松、莊喆、李錫奇、秦松、陳昭宏、霍剛、蕭明賢、李元佳、陳道明等。甚至吸引外國大使館人士及外賓前來參觀。東方畫友經常在防空洞集會，討論、創作，這段時期，對於促進現代繪畫的發展有很大的影響。他們在防空洞工作室長達七年之久，在當時的畫壇上傳為美談。

台灣現代美術史發展脈絡中，「東方畫會」以現代抽象繪畫為目標，他們舉辦展覽傳達前衛理念，其階段性的歷程，從1957年首屆展出到1971年為止，歷經15年共計舉辦了15屆展覽，其間陸續加入的會員，也都各自卓然成為現代重要的藝術家。本展為進一步認識藝術家的成長背景，以下分別論述探討東方「八大響馬」的創作歷程與個人風格，希冀有助於欣賞瞭解觀看的視角。

李元佳→提鍊思想的觀念藝術家

李元佳(1929~1994)是一位極富原創心靈與敏銳的藝術家，創作表現形式的風貌，從墨點與虛實空間、物體與環境構成、乃至全方位的觀念行動藝術，含蓋他極目所見之萬物皆視為探討的作品，他的超越思想特立獨行與行徑，可視為早期的觀念裝置藝術家。1949年，李元佳自從中國大陸輾轉來台灣，曾向李仲生學畫而開啟觀念，鋪陳自我風貌，之後為追尋創作自由氣息前往歐洲在義大利波隆納停留四年，因展覽的機緣再赴英國倫敦郊區定居長達近三十年之久。儘管李元佳歷經東西方文化的融會激盪，然而其創作核心觀念仍明顯透露以東方哲學為精髓。李元佳曾於英國倫敦知名的里森現代畫廊〔Lisson Gallery〕舉辦個展三次，其中最後一次於1969年的「金月」〔Golden Moon Show〕裝置性個展，由三個部分組成：人類在月球 =人類於星球，生命站與宇宙=一體。在西方六〇年代的前衛藝術進展，李元佳不僅是時代目擊者且參與大潮流的波動身歷其境，更體悟作為一個東方畫家如何以本位角度發言，促使李元佳從理性繪畫構成繪畫表現發展至三度空間衍生至環境藝術的實驗性探討。李元佳以極簡的墨點表現自由獨特的觀念，它是物理及形而上的藝術象徵，他稱之為"宇宙點"，以此符號彰顯隱喻無限浩瀚的宇宙空間。李氏晚年使用的創作形式更加自由而寬廣，含蓋了繪畫、浮雕、攝影、詩句、版畫、木頭以及金屬磁鐵等複合媒介，例如：系列大圓盤上置放帶有圖象磁性的小圓形、方形以及三角形，觀者可以任意思考移動方位構成心目中理想的城池，使用點陣元素連接空間與時間的經驗，他們以相異的思維改變了難以預測不確定關係。此次展出李元佳繪於絹本上的冊頁與極簡墨點系列作品，展現了其觀念藝術的思想精神面貌。

歐陽文苑→寓樸素於空間之鑲嵌繪畫

歐陽文苑(1928~2007)的作品具有沉鬱蒼茫的意境。他是一位感知敏銳的藝術家，在八大響馬當中，他最早接處觸李仲生而成為入室弟子，繼而引介霍剛向李仲生習藝，他們知道如何追尋思想觀念的啟發者，堪稱是藝術家中的早覺者。在六〇年代時期，歐陽文苑最初的創作媒介是以水墨開始探索，繼而再以油畫表現近乎理性的構成繪畫。從其水墨畫作顯示，黑白墨色鮮明極富暢快且甜暢淋漓，甚至輔以拓印的技藝痕跡，抽離自然物象的自由書寫，從傳統水墨的形象突圍而出，無疑地，這是屬於東方式的抽象表現繪畫。本次展覽非常難得向其東方畫會的藝術家友人洽借1986年未曾展出的四件系列油畫作品，灰色、墨綠色與少許點點的暗紅色，成為畫面構成的重要視覺元素，方形與矩形造成封閉的空間，亦為主要的結構體，薄層染色彩的透明流動感，如同水墨質素的底蘊，相互交錯鑲嵌，這些線與形狀的接觸邊緣，流露出隨意而不假修飾的筆觸，令人隱約感到有機擴張的空間藍圖。歐陽文苑將繁複的造形逐漸構成專橫形式，並萃煉出其內在本質，亦即凝結為抽象變化的色塊體系，整幅畫面彷彿重返原初的天然礦脈幻化成寶石精靈，等待有識者挖掘、採集。

吳昊→汲取民族色彩蛻變為現代繪畫

吳昊的繪畫作品，無論是人物或是花卉，造形鮮明且色彩豐饒。初始以版畫為創作媒介，反映民間鄉土樸素的韻味，呈現歡欣豐盛的和諧景象。在七〇年代中期，開始以油畫表現抒發人間世的各種物象，線描、亮麗色彩與童趣造形，是構成吳昊作品的特色。1932年吳昊出生於南京市。1948年就讀蘇州省立工專預備科，之後到上海搭乘輪船來台。1951年進入李仲生畫室習畫，進而結識李元佳、歐陽文苑、霍剛、夏陽、蕭勤、陳道明、蕭明賢。吳昊早期的作品介於超現實與抽象之間，具有東方古樸之神秘意境。吳昊擷取古文物與民間廟宇彩繪的

色彩，例如：紅綠相映、綠色與桃紅色互襯、寶藍妝點深黃，這些色彩顯得十分迷人，然而畫面上的構圖總是以"飽滿"物象佔據整個畫面，在視覺上形成強烈壓迫感之張力。吳昊擅長以黑線勾勒形體，細線融入畫面似有若無，並以濃郁的色彩賦予繁飾容貌，尤其描繪人物的頭呈現歪側，如同木偶擺動的特質，而臉部的表情總是綻放著青春喜樂，整體畫面洋溢著熱鬧與喧嘩的氣氛，無疑地，吳昊緬懷家鄉的氣息並喚起了生活記憶中的圖像，他藉由奇觀式的造形與構圖，畫出了自己的感覺，從而建立獨特的藝術語彙。本展作品〈舞〉、〈繁花〉與〈捧花女孩〉展現了吳昊極為富麗形色翩翩的視覺風貌。

夏陽→將生命苦澀化為毛毛人符碼

1932年，夏陽生於湖南湘鄉縣，1948年夏陽畢業於南京市立師範簡師。1963年末，初訪歐洲，後定居巴黎5年，1968年移居紐約，直至1992年返回台北定居，2002年遷居至上海至今，好比人倒吃甘蔗愈來愈見甘甜，其旅居的創作生涯，誠然應驗了"人挪活"的絕佳寫照。夏陽的繪畫題材內容，取自於民間宗教、神話、寓言故事及傳奇人物，他以顫動的線構成人形在空間穿梭，畫面中的毛毛人以寓言象徵表現超現實的意境，既擺脫物像原本的含意，同時亦象徵人處於都市叢林之不安與疏離感，毛毛筆觸轉變成似是而非的物象，鮮明的動勢牽引出敏感機智的圖像語言。七〇年代時期，夏陽旅居紐約期間，適逢照相寫實形成風潮，他的繪畫有不同的轉變，其描寫取景於人在都會景觀的片段，細膩刻劃場景以及快速局部模糊圖像的表現手法，如同影像突然停格般的視覺效果，或可視為毛毛筆觸的延伸與變奏。在九〇以後，夏陽的毛毛人系列，亦創作發展為雕塑，用鐵器形塑立體的毛毛人作品，兼具質感與量感更深化了其藝術語言。本展展出作品如〈獅子喞劍〉，以民間圖騰充滿動勢的毛毛人進出於虛幻的空間，迷漫詭譎的氣氛；又如在夏陽的名畫中，重新詮釋經典名作〈拾穗〉的圖像，人物的形象以毛毛筆觸，但臉孔與身體在金黃色的麥田中，卻呈現出莫名其妙的荒誕，觀其想像時空錯置之巧妙令人不覺莞爾。

霍剛→超理性與極激越幾何構成

1932年，霍剛生於南京，本名為霍學剛，後有感於"學"字之贅瑣，更名為霍剛，取其簡潔有力、鏗鏘響亮之意。1949年隨南京國民革命軍遺族學校來台。1950年霍剛被分發保送就讀台北師範學校藝術科（今國立台北教育大學）。1952年，霍剛經由歐陽文苑介紹向李仲生畫室研習。1964年，霍剛為了追尋創作的理想環境，離開了東方的土地遠至西方，初抵歐洲短暫停留在巴黎，隨即轉往義大利米蘭，在這個城市一住就是四十餘年，帶著東方精神的特質投入西方藝壇的翰海中。霍剛早期的繪畫多為捕捉"意象"，畫面上鳥獸變形體幽游於空間之中，充滿超現實風格的神秘性，色彩多為中性或低彩度光線較為陰暗，定居米蘭之後，延續超現實探索，但輪廓線趨向理性幾何抽象，這是建立其繪畫語言的轉變階段。換言之，六〇年代中期以後，霍剛畫作的表現形式已趨於硬邊構成，而精神上卻傾向於視覺詩性，圓點與線形色彩構築畫面，隱寓向隨機非可預期的動向空間，展現境外牽引，呈現畫外之意。霍剛顯然受到義大利深厚文化特質的移轉，他的繪畫展現沈潛而內斂，畫面看似輕盈的油彩，實則飽含心靈之厚度，從七〇年代的作品表現迄今，畫中色彩愈來愈濃烈鮮明，構圖也趨向明

「東方畫展」於台北新聞大樓, 1957
Oriental Paintings Exhibition at Taipei News Building in 1957

快簡潔，常見對稱性與突發性現身的點、短直線交替展現，有時線與塊面凝住對峙，閃爍的小點線一觸即發，激擾平靜寂浩瀚的畫面，卻又可發現這些靈活的小符號是拆卸了書法線條的重組樂章。在霍剛的觀念　，我們應該把著眼點從外形具象的所謂中國書畫　解放出來？霍剛在他的作品中表現出堅韌而又理性的繪畫語言，以不尋常的、非預期的形狀呈現一種謎樣的感覺。生命之於他，是一個單一而獨特的偶然存在，不只是在時間與空間想像的秩序中悠遊自得，同時也顯出豁達大度的人生觀。

蕭勤→凝聚鬆勁之東方禪道冥想

蕭勤(1935~)的人格特質，具有開放的胸襟和靈活的社交手腕，凡事都以積極達觀正向思考，在藝術界多方廣結善緣，他是東方八大響馬之中，最早奔馳至西方發展的藝術家，活躍於東、西方藝壇並積累顯赫的展覽資歷。蕭勤是促成「東方畫會」成立的重要推手之一。1957年首屆東方畫展在台灣舉行，蕭勤即引介西班牙14位現代藝術家和東方諸子共同展出，也就是說，「東方畫會」一開始就是以國際交流展的姿態出現，在當時確有別於其他畫會，展現不同凡響的藝術社團。1952年，蕭勤由同學介紹進入李仲生畫室習藝。1956年，蕭勤至西班牙留學，在思想與觀念視野上是重要的轉捩點。大約於六〇年代，蕭勤雖身處於西方文化環境，卻開始嘗試從東方道家思想去尋求精神內涵。蕭勤的作品，以排筆霑墨水在棉布上書寫出緩和的帶狀曲線，圓點或方形與長條造形，在畫面上構成均衡空間，時而以中文字強化融入畫面，例如：氣、道曲然、進焉、絕然、掩然、浩然、混沌初開、大方無隅…… 等等，這一系列作品具有書法筆觸的墨線自然而帶有飛白皴的韻律感，書寫流動意象的線條湧現出"曲則全"的勁道與抒情興味，既隱含東方的哲學精神，且表現出藝術家體悟的人生境界。蕭勤的繪畫融合東西方的表現形式，逐漸形成其藝術身份與語言之獨特性。又蕭勤以"太陽"為探究題材，從六〇年代中期迄今似乎未曾間斷。"太陽"系列作品，以一個幾何的圓為中心，色彩鮮麗，周邊許多放射狀的現線條伴隨著白色的斑點，構成太陽意象，象徵畫面肌理之不可預測性，蕭勤欲傳達一種未知的、神秘的、熾烈而具有擴張的思想，它既是"空無的"又是"豐沛的"，同時亦隱含"內聚"與"流動"的巨大能量。

陳道明→以繪畫表現萬物抽象的本質

在東方「八大響馬」當中，陳道明是唯一的北方人，天生豪爽與率直的個性及其行事風格，堪稱是道地的北方青年；他的繪畫內容與質感，以自然大地穹蒼為簾幕，表現出無盡的靈感養份與紋理。1933年，陳道明生於山東濟南，他在18歲時，隨同家人來台就讀於台北師範學校藝術科(今國立台北教育大學)。五〇年代，陳道明受到李仲生教學啟發的影響，他開始以潛意識作畫，抒發內心澎湃豐富的情感，其畫風演變軌跡，從立體派技藝蛻變至抽象符視界，同時參與「東方畫會」的展覽活動，陳道明表現出積極熱情的激進藝術家。陳道明的創作信念始終抱持：絕對抽象的心靈空間，在其創作理念述及：『作品的意義是心靈意識活動的一種記錄，原則上是抽象的，我在表達內在生命意象的過程中，盡量不受任何干擾，以求達到沒有結論又有結論的境界……』。陳道明擅長以複合材質實驗繪畫，主觀意識輔以自動書寫技能，使畫面產生多層層疊疊的肌理，進而構成其抽象繪畫語言。本展向收藏家借展陳

道明在1959年早期的抽象畫作〈探險者〉，該畫以油彩及複合材質烘托出粗獷厚實的皺褶肌理，黝黑斑駁沉積的色調透露出迴光的映照，猶如遙遠的圖騰印記，觀讀其畫令人頗有發思古之幽情。

蕭明賢→線形語言擴及延異空間

東方八大響馬來自於四面八方雲集於台北，其中蕭明賢(1936~)最年輕也是唯一的台籍青年，其他七位都來自大陸各地。1953年，蕭明賢十七歲即隨李仲生在安東街畫室習藝，開啟了他的藝術觀念與繪畫根基。1964年，蕭明賢遠赴法國巴黎追求藝術夢想，從此開始羈旅海外將近半個世紀的漫長生涯。1957年，蕭明賢的作品〈#5607構成〉以黑線圍砌劃出編織的色面空間，觀畫面結構，顯然受到瑞士藝術家保羅‧克利(P. Klee)的影響；該作品曾入選參加巴西聖保羅第四屆國際雙年展，並獲榮譽獎章，在當時獲得國際獎是難得的藝術殊榮。蕭明賢的作品初始也以抽象水墨表現夢幻詩情，線形與團塊墨韻交集成抽象空間，他用線條在宣紙上或在畫布上，鉤勒出自然形象以外的另類造形，粗線條、細線條在不同的媒材上產生律動變化的視覺符號，令人印象相當深刻。蕭明賢曾多次參與「東方畫會」在台灣以及海外的展出，但其作品自始至今延續早期抽象語彙的面貌。自1969年以後，從歐洲移居美國紐約持續創作與生活，其間蕭明賢雖然鮮少在台灣發表作品，然而創作的熱力顯然積蓄良久，此次展出蕭明賢其中的畫作〈時空記憶之五〉、〈時空記憶之八〉、〈黑色的絃律〉，皴擦點染印拓、色澤清雅與　朗無垠的時空韻致，充分展現其與生俱來的繪畫才情。

本展主辦大象藝術空間館藝術總監鍾經新致力推展現當代藝術與學術研究為取向，尤其關注台灣美術史精彩之篇章。「藝拓荒原→東方八大響馬」展舉辦之意義，在於經由東方八位藝術家的歷史性作品，透析檢視其豐富多變繽紛而自由的藝術精神，具有研究探討藝術橫切面的實質意涵。除了欣賞他們的藝術風格與所經歷的時代背景，同時有助於瞭解東方諸子在台灣美術現代化運動過程中的演變軌跡。回顧東方八大響馬半世紀以來創作的激情與執著，不斷燃燒的是，他們的創作力和闖蕩藝壇的勤奮態度，我們似乎感受到了瀰漫歷史的氣息，以及藝術家在錘鍊生命和傾注智慧之後，所揉合成那股巨大深層的力量。

註1. 《五月與東方—中國美術現代化運動在戰後台灣之發展(1945-1970)》蕭瓊瑞著，東大圖書 出版. 1991.11

註2. 《第一屆東方畫展—中國、西班牙現代畫家聯合展出》展覽目錄. 1957.11

Exploring the Wasteland –
The Eight Highwaymen of the East

Liú Yung-Jen / Curator

Introduction

The Taiwanese modern art environment of the 1960s was a wilderness of empty fields, just like eastern Taipei in those days. Young artists desired to create and longed to break beyond establishment norms, to express themselves freely and vitally. Yet in the social atmosphere of that era, freedom was a form of danger, and if one created freely, to display one's art publicly required courage. The entire atmosphere of the art world was conservative and infertile, in a state of desolation. Yet one group of young artists pitted their own wild vitality against the establishment and its views. Looked at from the present, they seem epic and virile, affirming what it means to explore the wasteland.

The Ton Fon Art Group officially formed in November of 1956. The core members of this Taiwanese modern art collective were: Li Yuanchia, Oyan Wenyung, Wu Hao, Ho Kan, Hsia Yan, Hsiao Chin, Chen Taoming and Hsiao Minghsien. They believed in free innovation, and strove at their art with a flourishing, combative spirit and bold bursts of energy, earning the sobriquet "the Eight Highwaymen." Prior to the opening of the Ton Fon Art Group's first exhibition, the writer He Fan published an article introducing the new group to the general public. Titled "Highwayman Exhibition," it appeared on November 5 and 6, 1957 in his column "On the Glass Placemat" in the United Daily News literary supplement. Writing in a playful tone, Ho referred to the group's founders as "the Eight Highwaymen," employing the Chinese word xiangma, a kind of bandit of northern China with the custom of shooting a whistling arrow as a warning before launching an attack. This depiction reflected their roving, rebellious character, and for the ensuing half century, "the Eight Highwaymen" has been an alternative epithet for the Ton Fon Art Group.

In recent years, documentary research and discussion of the Ton Fon Art Group has become increasingly plentiful; nevertheless, few exhibitions dedicated to them have been unveiled to the public. During the curatorial process for this exhibition, borrowing early works of the Ton Fon Art Group proved quite challenging. In addition to contributions from the artists themselves, their friends and collectors in Taiwan, collectors as far away as Italy lent early works of Hsiao Chin and Ho Kan, and it is due to their generous efforts and assistance that the group's works have been gathered together and presented in comprehensive form. This exhibition places special emphasis on reproducing the originality and fresh character of these eight artists. Although they all belonged to the same group, their individual modes of thought and methods varied widely. Particularly during the conservative post-war era, their thinking and their art trailblazed the wilderness for modern art on this island, and opened up a new window of art for people's customarily ossified visual spirits.

Painting amidst a Conceptual Transformation

The cradle of Taiwanese modern art can be traced back to Taipei's Andong Street, and the studio of Li Chuhshan. His inspirational teaching and creative concepts deeply influenced the

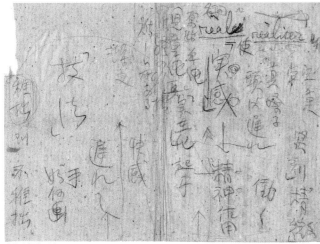

李仲生教學手稿
Manuscript by Li Chuhshan

subsequent evolution of the artistic lives of the Ton Fon Art Group. An intellectual pioneer of modern art, Li centered his pedagogical methods on the idea of coordinating the brain, eyes, mind and hands. He emphasized beginning with linear drawing, or so-called "mental image sketching," that is, the attempt to unearth the true latent capacity of the inner mind. He employed psychology to understand his students' personalities and native qualities, stimulating their creative powers and transmitting spirit through thought. Only through a creative attitude – that is, the vitality of thought and the vitality of life, allowing thought to serve as the foundation, could art be robustly infused with an unceasing life force. Worthy of special attention was that while the Eight Highwaymen all studied under Li Chuhshan, they did not imitate his style, but developed their own visions, manifested in a rich diversity of painting styles. This was something rarely witnessed in that era.

The Spirit of the Ton Fon Art Group

As for the origins of the group name, early suggestions included the "1957 Art Group," the "Pure Art Group" and the "Andong Art Group," but finally, Ho Kan suggested "Ton Fon Art Group" (literally, "Art Group of the East"), referring metaphorically to: (1) the sun rising in the east, with the dynamism of daybreak, symbolizing the power of new artistic life, and (2) the Far East as the place where the group members were all born and raised, as most of them centered their creative output on an expression of the Oriental spirit. (Note 1) The catalogue for the first Ton Fon Art Exhibition included a declaration titled "Our Words," the rough draft of which was penned by Hsia Yan. This was a statement of exploratory idealism, intended to usher in a new mode of thought about art: "...All that has transpired in the 20th century has already influenced us. We must enter the environment of the present era, and stay abreast of the currents in the world today, absorbing new concepts all the time. Then we will be able to develop and create. In the realm of art, if we were to only preserve old forms, we would surely stifle the growth of Chinese art, not only perpetually impeding the spirit of tradition from being expressed, but indeed inevitably causing its gradual decline..." At the same time, they stressed the value of the traditional Chinese spirit: "...China's traditional view of painting is fundamentally in accord with the modern international perspective of painting. The two only differ slightly in terms of forms of expression. If modern painting were to become widespread throughout our land, the limitless artistic treasures of China would surely gain a presence in present-day world trends with a brand new bearing..." Their artistic stance proclaimed the value of a free spirit: "...True art is absolutely not a product of the so-called ivory tower, nor is it a tool of self-intoxication. Rather, it is meant for the appreciation of everyone. However, we oppose the communist, collectivist fallacy of mass art, because this reduces the aesthetic diversity that people need and shrinks people's aesthetic scope. Is this not a suppression of the human spirit? We believe the correct approach to be the aestheticization of the general public. This will serve powerfully to cultivate good character, and also present a vast panoply of art before the people's eyes. Only in this way can we set people's visions free, and allow their spirits to enjoy boundless expansion..." (Note 2)

The Air-raid Shelter: Residence and Shared Learning

Art requires room to think and to paint. The studio is the venue where the painter thinks and nurtures his works. In 1952, Wu Hao, Oyan Wenyung and Hsia Yan first moved into an air-raid shelter to do their painting. Choosing an air-raid shelter as a studio and a location to talk about art theory can be seen as a classic early example of re-utilizing an abandoned space. The air-raid shelter they occupied was located on Longjiang Street in Taipei. A flat-roofed cement structure left over by the Japanese, with thick cement walls, only two doors and no windows, it may have been intended for storing valuables in the event of a bombing. The air-raid shelter was managed by military officials for the evacuation of military families, but on ordinary occasions was left empty. At the time Wu, Oyan and Hsia were all three performing military service, and every day after work as well as on their days off, they would all paint in the shelter, as its management was under the charge of Wu Hao, then a second lieutenant in the air force. The space was over 1400 square feet and had electric lighting, allowing for painting at night. Using the shelter as a studio, each of the three had their own space, so they did not disturb one another. Many other fellow painters often gathered there, and at Christmas they organized parties and dances. Painters who were regular guests included: Hsi De-Chin, Fu-sheng Ku, Liu Kuo-Sung, Chuang Che, Lee ShiChi, Chin Sung, Hilo Chen, Ho Kan, Hsiao Minghsien, Li Yuanchia and Chen Taoming. Even foreign dignitaries and embassy personnel were drawn to the air-raid shelter. Members of the Ton Fon Art Group often gathered there to discuss and do art. During this period, they had a big influence on the development of modern painting. The air-raid shelter served as a studio for seven years, and was the subject of acclaim in painting circles of the day.

In the developmental trajectory of Taiwanese modern art history, the Ton Fon Art Group took modern abstract painting as their goal. To convey their avant-garde ideas, they held 15 exhibitions over the course of 15 years, progressing sequentially from the inaugural exhibition of 1957 through 1971. During this time, they continually added new members, each becoming prominent modern artists in their own right. In order to afford greater familiarity with the artists' backgrounds and personal fruition, this exhibition separately considers the artistic evolution and individual style of each of the "Eight Highwaymen of the East," with the aim of facilitating the viewing of their works with a perspective of greater appreciation and understanding.

Li Yuanchia – Conceptual Artist, Refiner of Thought

Li Yuanchia (1929-1994) was an artist with an abundantly original spirit and acute perception. His forms of creative expression spanned ink points, spaces of counterbalanced solidity and emptiness, compositions of objects and environments, and even multi-dimensional conceptual art actions. He viewed absolutely everything within his scope of vision as an artwork to be explored. With his penchant for thinking outside the envelope and his independent character and conduct, he may be viewed as an early conceptual installation

artist. Li fled mainland China in 1949, eventually arriving in Taiwan. His concepts were inspired by his painting studies under Li Chuhshan, expressed in his own style. Later, in pursuit of an atmosphere of creative liberty, he traveled to Europe, living in Bologna, Italy for four years. Given the opportunity to exhibit his works in England, he moved to the suburbs of London, and remained in England for nearly three decades. Even though Li experienced the blending and turbulent interaction of cultures East and West, the core concept of his art still clearly revealed the essence of Oriental philosophy. He held three solo exhibitions at London's renowned Lisson Gallery. The last of these, Golden Moon Show of 1969, was a solo exhibition of installations, organized in three distinct "environments": "Man on the moon = men in the stars," "Life station" and "Universe = one." Li Yuanchia not only was a witness to the evolution of avant-garde art in the West of the 1960s and indeed a participant in its many fluctuating movements, but also comprehended how to voice his own perspective as an Oriental painter. This led him to move from expression through paintings with rational compositions into experimental explorations of three-dimensional spaces and eventually to environmental art. Li expressed a free and unique perspective using minimalist dots of ink, which served as both physical and metaphysical artistic symbols, which he termed "cosmic points." He used these symbols to metaphorically express the boundless magnitude of the universe. In his later years, Li became even freer and more wide-ranging in the art forms he employed, encompassing painting, relief, photography, poetry and print, as well as mixed media using wood, metal, magnets and other materials. For example, on a series of large round plates he placed round, square and triangular magnets with images on them, the positions of which viewers could move as they pleased to compose ideal towns from their imaginations, using a matrix of elements to connect spatial and temporal experiences. Through disparate modes of thinking, they altered unpredictable and uncertain relationships. This exhibition presents an album of painted scrolls as well as works from Li's minimalist ink point series, revealing the thought, spirit and appearance of his conceptual art.

Oyan Wenyung – Paintings Inlaid with Unembellished Spaces

The works of Oyan Wenyung (1928-2007) present a profoundly vast world of mental images. He was an artist of acute perception. Among the Eight Highwaymen he was the earliest to come into contact with Li Chuhshan and study under him in his studio. Subsequently, he brought Ho Kan along to study under Li as well. These two were early initiators who knew how to pursue intellectual concepts, and were even considered to be among the "first enlightened" artists of their time. The first medium with which Oyan Wen yung began experimenting in the early 1960s was ink painting, and thereafter he went on to work with oil paints, producing almost purely rational compositions. The sharply defined black and white tones of his ink paintings were richly joyful and vivaciously uninhibited. They were even augmented by the traces of rubbings, and spontaneous renderings moving away from the imagery of natural objects, breaking beyond the image of traditional ink painting. Undoubtedly, this was a form of Oriental abstract expressionism. This exhibition is fortunate

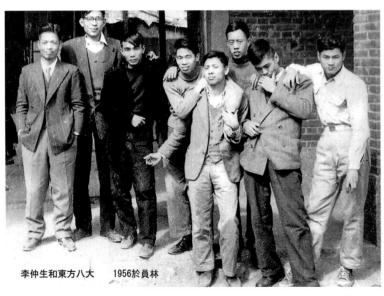

李仲生和東方八大　1956於員林

李仲生和東方八大_1956　左起：李仲生.陳道明.李元佳.夏陽.霍剛.吳昊.蕭勤.蕭明賢　攝影：歐陽文苑
Li Chuhshan and the Eight Highwaymen in 1956 From left side, Li Chuhshan, Chen Taoming, Li Yuanchia,Hsia Yan, Ho Kan, Wu Hao,Hsiao Chin, and Hsiao Minghsien. Photo by Oyan Wenyung

to feature a rare series of four oil paintings from 1986, borrowed from a friend of the artist and never before exhibited. Gray, inky green and a few focal points of dark red serve as the primary visual elements of the paintings' compositions. Squares and rectangles forming closed-in spaces constitute the main structural elements, mutually juxtaposed and inlaid with thin layers of colored dye that lend a translucent sense of motion, like the implied essence of calligraphic ink. The borders where these lines and shapes intersect reveal unprompted and unembellished brush textures, yielding a faint sense of organic expansion from a spatial blueprint. Oyan's reiterated forms gradually comprise magisterial structures, distilled into a fundamental inner quality, coalescing into an abstract system of shifting color fields. These pictures as a whole seem to revisit primordial mineral veins of nature magically transformed into fairy gems, waiting for those with knowledge to dig them up and gather them.

Wu Hao – Ethnic Hues, Metamorphosed into Modern Painting

Whether his subject matter was human figures or flowers and plants, Wu Hao's works contained vivid forms and rich colors. His first medium was prints, reflecting a poetic flavor of folksy rusticity, depicting happy, luxuriant scenes of harmony. In the mid-1970s he began to use oil paint to portray a variety of images from everyday life. Line sketches, vivid colors and shapes with childlike appeal constituted the special character of Wu's works. Born in Nanjing in 1932, Wu Hao studied in the preparatory program at Suzhou Provincial Vocational School. Later, he traveled to Shanghai and then via steamship to Taiwan. In 1951 he began studying painting under Li Chuhshan and subsequently became acquainted with Li Yuanchia, Oyan Wenyung, Ho Kan, Hsia Yan, Hsiao Chin, Chen Taoming and Hsiao Minghsien. Wu's early works were somewhere in between surreal and abstract, expressing simple yet mysterious images with an Eastern sensibility. Wu appropriated colors from antique artifacts and the paintings in neighborhood temples – for example, complementary red and green, contrasting green and magenta, or sapphire embellishing a deep yellow. These colors were extremely enchanting, yet his compositions were packed full of objects occupying the entirety of his pictures, forming a powerfully claustrophobic visual tension. Wu Hao excelled at using black lines to outline shapes. His thin lines seemed to blend into his pictures almost invisibly, endowing his dense colors with complexity. Distinctively, he often portrayed the heads of people flopping sideways like swinging marionettes, their facial expressions always exuding youthful joy. His paintings as a whole brimmed with a boisterous, clamorous atmosphere. Certainly, Wu's nostalgic longing for his hometown awakened images from his memories of daily life. Through spectacular forms and compositions, he painted his own feelings, thus creating a unique artistic vocabulary. His works featured in this exhibition, Dance, Blossoming Flowers and Girl with Bouquet manifest Wu Hao's visual style of extravagant, exuberant forms and hues.

Hsia Yan – Transforming the Bitterness of Life into the Symbol of Fuzzy People

Born in Xiangxiang County, Hunan Province, China in 1932, Hsia Yan graduated from Nanjing Normal University in 1948. At the end of 1963, he visited Europe for the first time, and later settled in Paris for five years. In 1968 he immigrated to New York, where he lived until 1992, when he returned to Taipei. In 2002 he relocated to Shanghai, where he has resided to the present day. Just as sugar cane tastes sweeter the longer one chews it, so Hsia's expatriate life of artistry has truly realized exceptional depiction of "people alive in motion." Hsia draws the subject matter of his paintings from popular religion, mythology, fables and legendary figures. He employs vibrating lines to compose human figures moving about within spaces. The "fuzzy people" in his pictures serve as metaphors or symbols, expressing a realm of surreal imagery, and by breaking away from the original state of physical images, he also symbolically represents the unsettled alienation of people living in the urban jungle. His blurry brushstrokes are transformed into illusory forms, vivid motion producing an acute, agile language of visual images. In the 1970s while Hsia was living in New York, photo realism came into vogue, effecting a sea change in his painting style. His pictures borrowed from segments of urban settings, portraying scenes in fine detail with a method of expression in which portions of the images rapidly blurred, producing a visual effect like a suddenly stopped film image. This could also be seen as an extension and variation of his fuzzy brushstroke. In the 1990s and thereafter, Hsia Yan took his "Fuzzy People" series into the medium of sculpture, forming three-dimensional figures with pieces of iron, deepening both the texture and the volume of his artistic vocabulary. This exhibition presents works such as Lion Clenching Sword in Teeth, in which a folk totem full of motion enters and exits an illusory space, evoking an indistinct, weird ambiance. In one of Hsia's more well-known paintings, which reinterprets the classic work The Gleaners, images of human figures are rendered with fuzzy brushstrokes, yet their faces and bodies, set amidst a field of golden wheat, exhibit an absurd surreality. This inventive juxtaposition of imagined spaces creates a humorous effect.

Ho Kan – Hyper-rational, Trans-geometrical Compositions

Ho Kan was born in Nanjing in 1932. Originally christened Ho Hsueh-kang, he later shortened his name to Ho Kan, which he found simple, powerful and resonant. In 1949 he relocated from Nanjing to Taipei along with the National Military Orphans' School. In 1950 he was selected to attend National Taipei Teachers' College (today's National Taipei University of Education). In 1952 Ho Kan began studying painting under Li Chuhshan, through an introduction from Oyan Wenyung. In order to pursue an ideal environment for his art, Ho traveled to Europe in 1964, first to Paris, where he resided for a short time before moving to Milan, Italy. In that city, he lived for over 40 years, joining in the Western art world with works of a distinctly Eastern quality. Most of Ho's early works captured "mental images." The transmogrified forms of birds and beasts roamed the spaces of his paintings, in a surrealist mode brimming with mystery. His colors tended to be of medium to low chromatic saturation and relatively dark. After settling in Milan he elaborated upon his surrealist explorations, yet his outlines tended toward rational geometrical abstraction. This was a period of transition in the formation of his artistic vocabulary. In other words, following the mid-1960s, Ho Kan

moved in the direction of compositions with hard edges, and a spirit of visual poeticism. Structures composed of colored circles and lines implied spaces moving in random and unpredictable directions, manifesting forces acting from outside the frame and expressing the significance of things external to the picture. Ho's art was clearly influenced by Italy's rich culture, and his paintings exhibited subtlety and restraint. While his oil colors were light and graceful, they nonetheless conveyed considerable depth of spirit. From the 1970s to today, his colors have become increasingly dense and bright, his compositions increasingly lissome and minimal, frequently expressed in symmetrical, spontaneously manifested points and overlapping short, straight line segments. Sometimes lines and fields freeze in mutual opposition. Scintillating points and lines suddenly materialize, disrupting a tranquil, expansive image. Yet at other times, one discovers these supple little symbols serving as a reassembled musical movement of disassembled calligraphic lines. According to Ho's conception, should we liberate the eye from the external, concrete forms of so-called Chinese calligraphy and painting? In his artworks Ho Kan reveals a resolute, rational vocabulary, expressing a sense of enigma through unusual, unpredictable shapes. For him, life is a singular and unique existence of coincidence, not only a contented journey through an imagined order of time and space, but also a magnanimous expression of humanity.

Hsiao Chin – Cohesion of Ease and Energy Informed by Oriental Meditative Thought
What gives Hsiao Chin (1935–) a unique character are his breadth of mind, finesse in social interactions, and an active, positive philosophical concern informing his every endeavor. Of all the Eight Highwaymen of the East, he was the first to gallop off to the West to develop his career as an artist. Active in the art circles of both the East and the West, he has accumulated an illustrious personal exhibition record. Hsiao Chin was one of the major instigators working to establish the Ton Fon Art Group. When the first Ton Fon Art Exhibition was held in Taiwan in 1957, Hsiao Chin brought in 14 modern artists from Spain to join in a group exhibition alongside the various Ton Fon members. That is to say, the Ton Fon Art Group organized itself as an exhibition of international exchange from the very beginning, setting itself apart from other art groups of the day and establishing itself as an exceptional art society. Hsiao Chin began studying under Li Chuhshan at his studio in 1952, through an introduction from a classmate. In 1956 he went to Spain for further studies, and the experience was a major turning point in his thinking and conceptual vision. During the 1960s Hsiao Chin began to experiment with Oriental Taoist thought as a source of inspiration and subject matter, even though he was living in an Occidental cultural environment. His works featured gently curving bands calligraphically rendered with brushes dipped in ink on cotton cloth, as well as circles, squares or long rectangles comprising balanced spaces on his canvases. Occasionally, he would add force to his compositions by blending into them Chinese characters such as "Chi," "The Curving Way," "Enter In," "Absolute," "Hidden," "Vast," "In the Beginning, Chaos" and "Boundless." This series of works included lines of calligraphic ink that naturally projected the rhythmic feeling of crinkled "flying white" brushstrokes. From these lines with the fluid

motion of calligraphy there wells up a vigorous, lyrical charm that is "partial yet complete," implicitly containing the spirit of Oriental philosophy while also expressing the artist's life experiences. Hsiao Chin's paintings merged the expressive form of East and West, gradually evolving into his own unique artistic identity and language. He has also engaged in a seemingly unceasing exploration of the sun as a subject, from the mid-1960s to the current day. Each of the paintings in his Sun series is centered on a geometrical circle, and on the periphery numerous lines radiate outward, accompanied by white speckles, forming a solar image of brilliant colors. Yet with the unpredictable textures of these symbolic compositions, Hsiao conveys a sense of the unknown – mysterious, burning and expansive. Both empty and overflowing, they imply an enormous force of cohesion and flow.

Chen Taoming – Expressing the Abstract Quality of the Myriad Things

Among the Eight Highwaymen of the Ton Fon Art Group, Chen Taoming was the only one from northern China. With a naturally ingenuous and forthright personality and way of dealing with people, he had the reputation of an authentic young northerner. The content and quality of his paintings arose from the natural heavens and earth, expressing limitless inspiration and creative permutations. Born in Jinan, Henan Province in 1933, Chen moved to Taiwan with his family at the age of 18, studying at National Taipei Teachers' College (today's National Taipei University of Education). Inspired by the instruction of Li Chuhshan in the 1950s, he began to delve into subconscious painting, releasing an upsurging abundance of inner feelings. His paintings evolved in direction, from cubist technique to a visual world of abstract symbols. In his participation in the Ton Fon Art Group exhibitions, he demonstrated his energetic passion as a radical artist. From beginning to end, Chen Taoming maintained his creative convictions: an absolutely abstract psychic space. He described his artistic ideas thusly: "The meaning of my artworks is a record of the activity of the soul and consciousness. In theory, it is abstract. In the process of expressing my inner life images, I avoid all interruption as much as possible, in the hope of attaining a realm that has no conclusion yet has a conclusion." Chen excelled at experimental paintings incorporating mixed media. His subjective consciousness was assisted by a method of automatic writing, causing multiple overlapping layers of textures to appear in his pictures, out of which arose his own abstract painting language. This exhibition features the early abstract painting Exploration from 1959, borrowed from a collector. The contrasting oil paint and composite materials in this painting yield a rough, thick, wrinkled texture. Its swarthy, mottled, sedimentary hues reflect light, as if the imprint of a distant totem, evoking a pensive mood redolent of antiquity.

Hsiao Minghsien – Linear Language Expanding into Other Spaces

The Eight Highwaymen of the East came from all points of the compass and converged in Taipei. Among them, Hsiao Minghsien was the youngest and the only Taiwanese native; the other seven came from various places in mainland China. In 1953 Hsiao Minghsien was 17 when he began to study under Li Chuhshan at the Andong Street studio, developing the beginnings of his artistic concepts and his foundation in painting. In 1964 he traveled to distant Paris in pursuit of his artistic dream, and from this time he embarked on a long life abroad that would span nearly half a century. His Composition #5607 of 1957, a space of interwoven color fields encircled by black lines, clearly reveals the influence of Paul Klee. This work was selected for participation in the 4th Bienal de São Paul in Brazil, where it received honorable mention. In that era, winning an international award was a very rare distinction for a Taiwanese artist. Initially, Hsiao also used abstract ink painting to express fantastic scenes and poetic sentiments, in which linear shapes and masses interlaced with the cadenced flow of ink to form abstract spaces. On either xuan paper or canvas, he painted the outlines of imagined forms not found in nature. Lines, alternately coarse and fine, formed visual symbols, engendering rhythmic changes in combination with different materials, to memorable effect. Hsiao Minghsien took part in several Ton Fon Art Group exhibitions, both in Taiwan and abroad, yet from the beginning to the present day, his works have consistently perpetuated his early-period abstract vocabulary. In 1969 he moved from Europe to New York, where he continues to live and produce art. During this period, Hsiao has rarely exhibited works in Taiwan; nevertheless, he has clearly been storing up creative calefaction for many years. Among the works by Hsiao featured in this exhibition, Memories of Time and Space 5, Memories of Time and Space 8, and Black Melody employ rough textural brushstrokes, refined details and rubbing techniques, light and elegant color tones and an expansive sense of time and space, amply manifesting the brilliance he has amassed over a lifetime.

Chung Ching Hsin, director of Da Xiang Art Space, the organizer of this exhibition, has devoted herself to promoting modern and contemporary art and scholarly research, especially exceptional chapters in Taiwanese art history. The significance of the exhibition Exploring the Wasteland – The Eight Highwaymen of the East lies in the historic works of these eight artists. By analyzing and surveying their rich, varied, flourishing and free artistic spirit, it is substantively meaningful for the research and discussion of a cross-section of art. It not only affords us a chance to appreciate the different styles of the Ton Fon Art Group members and the historical background in which they have lived, but is also helpful in comprehending their evolution and trajectory in the movement to modernize Taiwanese fine art. Looking back at the passion and commitment the Eight Highwaymen of the Ton Fon Art Group have shown toward creativity for the past half century, what they have constantly ignited is an assiduous attitude of creativity and a will to roam far and wide across the art world. We seem to feel an atmosphere diffuse with history, and an enormous and profound force that these artists have blended together, after being tempered by life and imbued with wisdom.

Note 1: Hsiao Chong-Ray , Fifth Moon and Ton Fon – The Chinese Art Modernization Movement in Post-war Taiwan, (Taipei: Tung Tai Book Company), Nov. 1991.
Note 2: The First Ton Fon Art Exhibition – Joint Exhibition of Chinese and Spanish Artists catalogue,Nov. 1957.

作 品
Works

李元佳
素描1
水墨 紙

Li Yuanchia
Drawing 1
Ink on paper
38x26.5cm,1961

李元佳

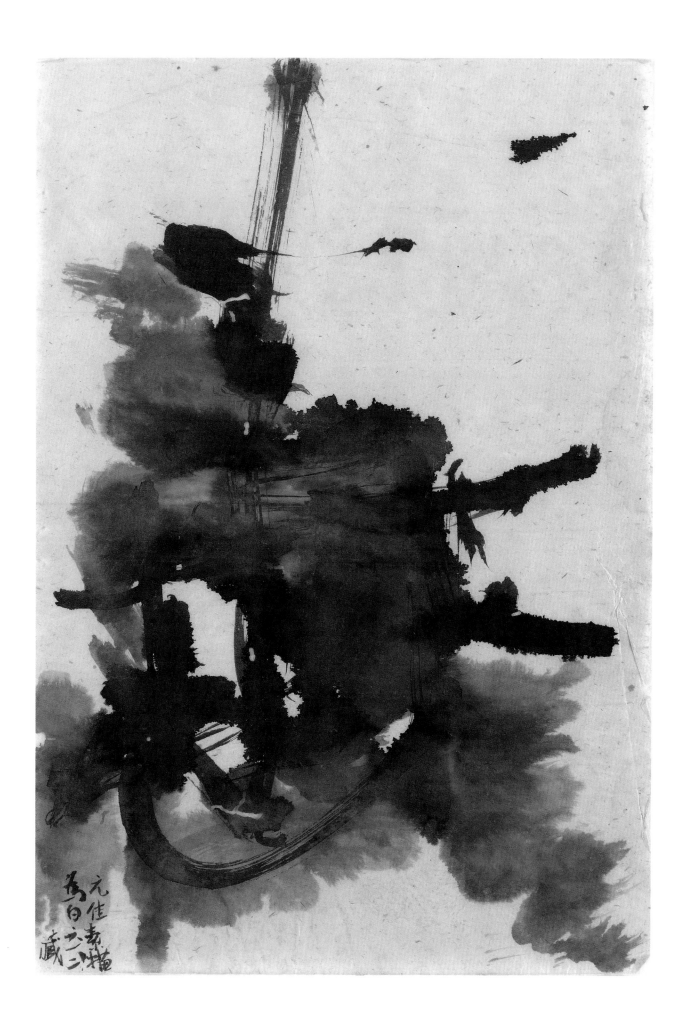

李元佳
素描2
水墨 紙

Li Yuanchia
Drawing 2
Ink on paper
38.5x26.5cm,1961

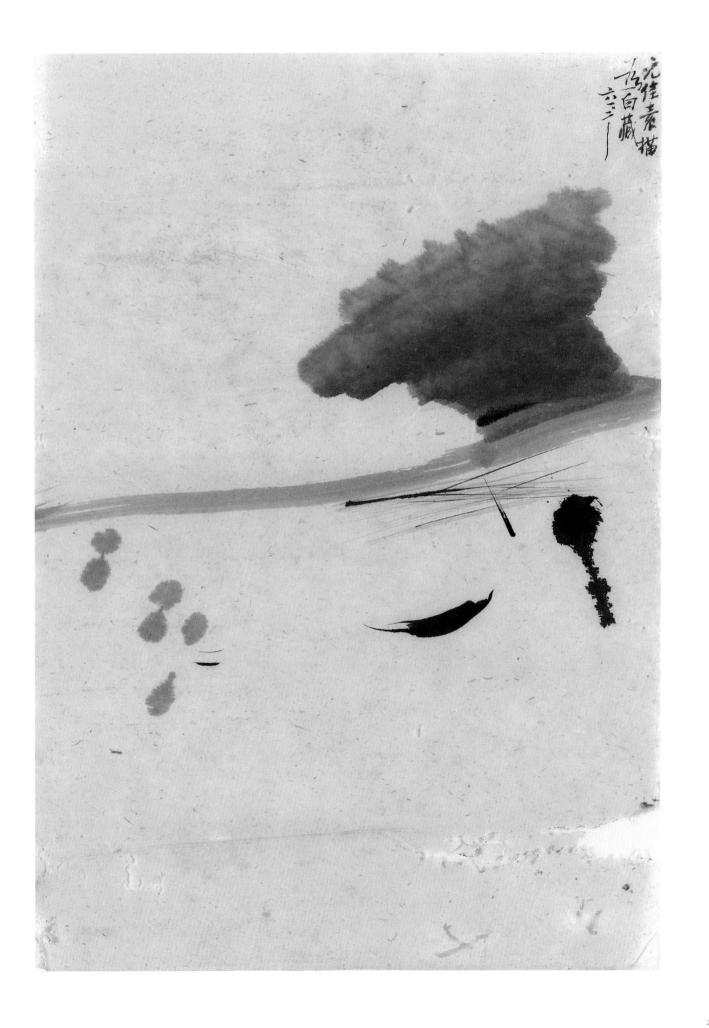

光华素描
松白藏
六三一

李元佳
素描3
水墨 紙

Li Yuanchia
Drawing 3
Ink on paper
38.5x26.5cm,1961

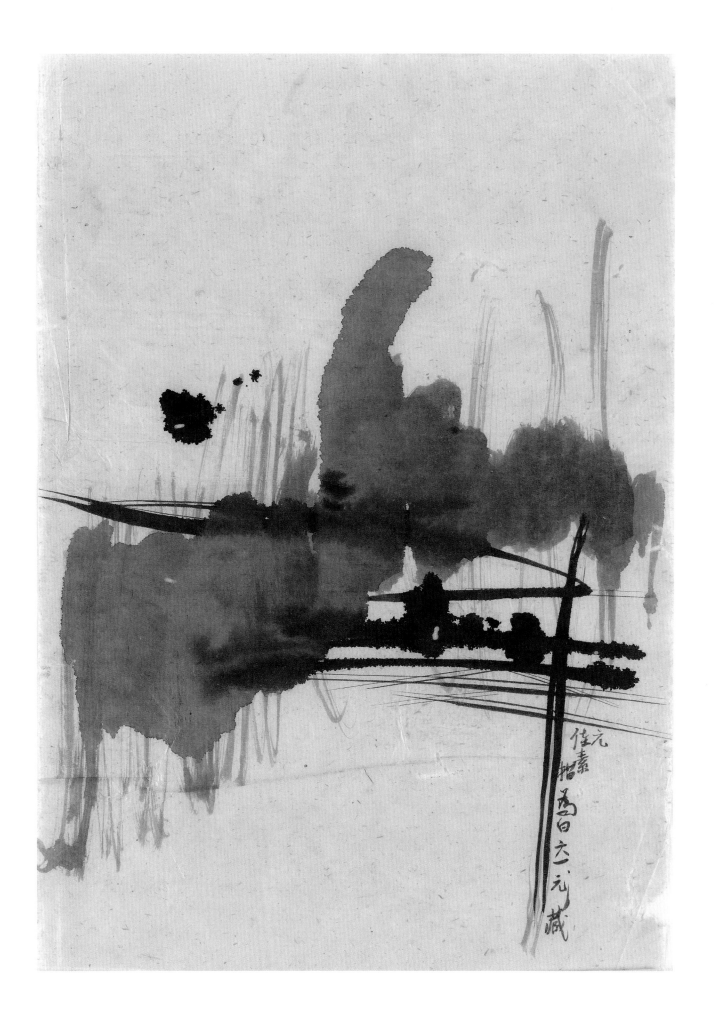

李元佳
素描5
水墨 紙

Li Yuanchia
Drawing 5
Ink on paper
38.3x26.5cm,1961

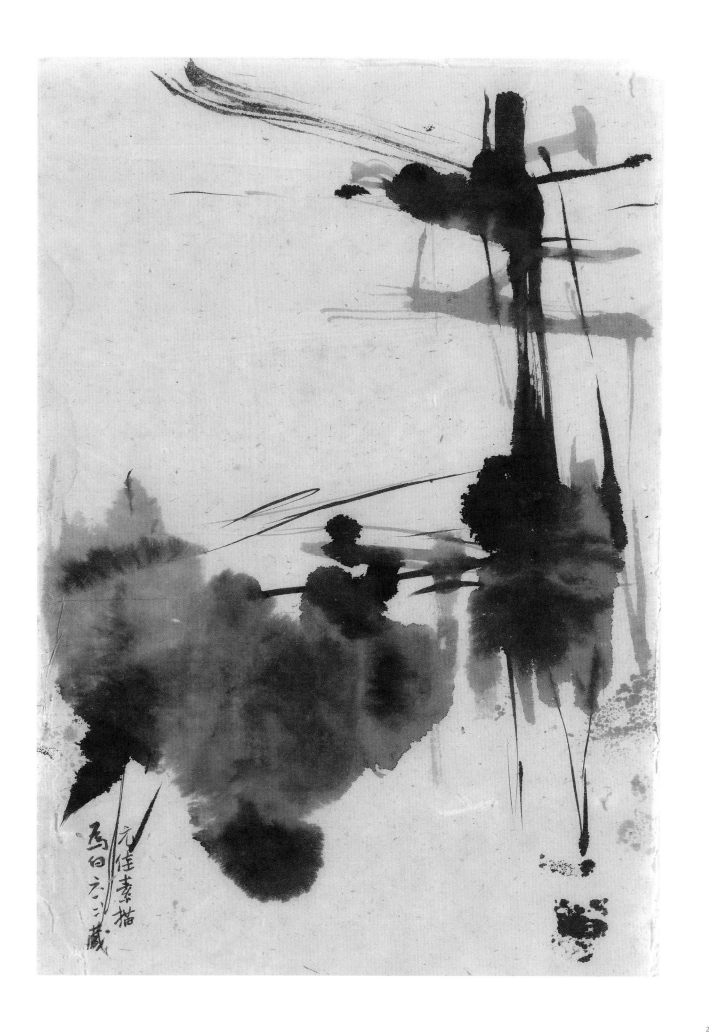

元佳素描
馬白水珍藏

李元佳
素描4
水墨 紙

Li Yuanchia
Drawing 4
Ink on paper
26.5x38cm,1961

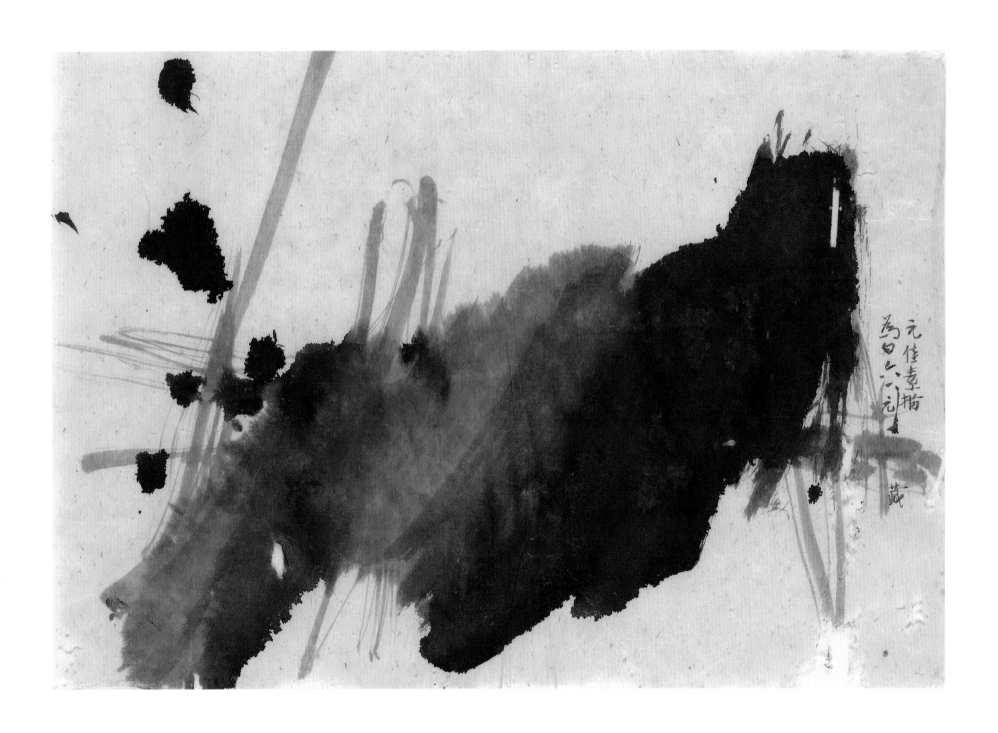

李元佳
素描6
水墨 紙

Li Yuanchia
Drawing 6
Ink on paper
26.5x38cm,1961

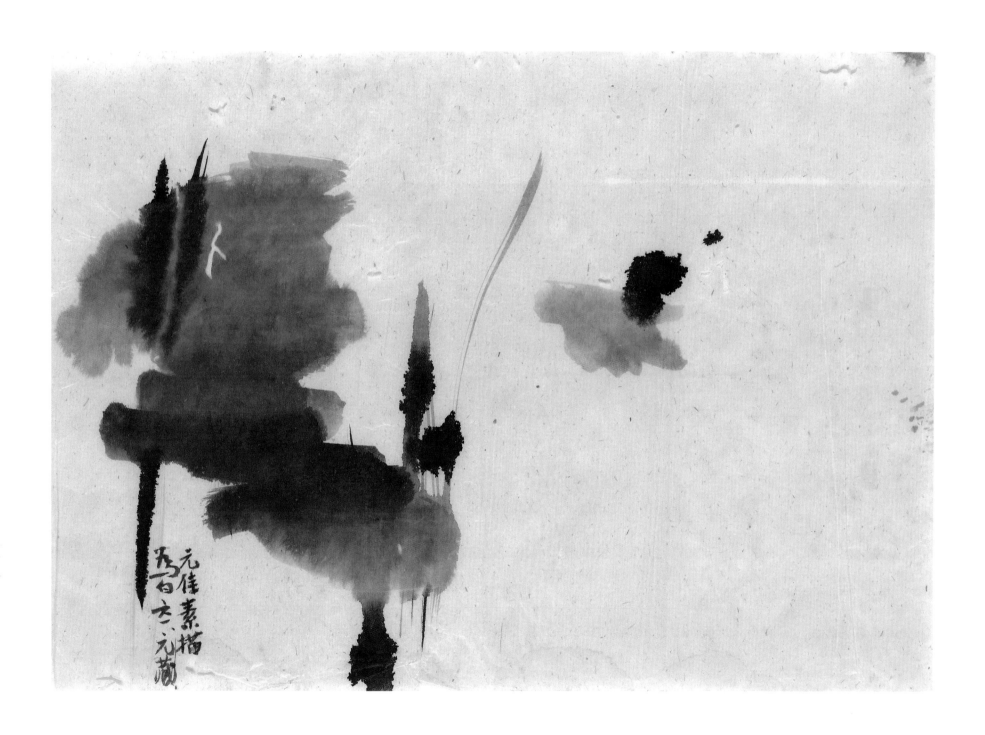

李元佳
宇宙點
水墨 絹本

Li Yuanchia
cosmic points
Ink on silk
29x40cm(each)x12pic,1961

陳道明
探險者
油彩 畫布

Chen Taoming
Adventurer
Oil on canvas
61x90cm,1959

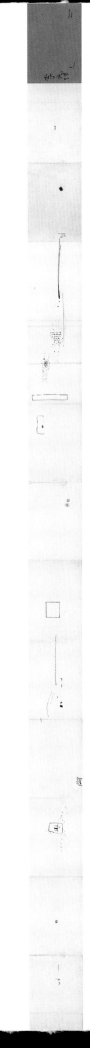

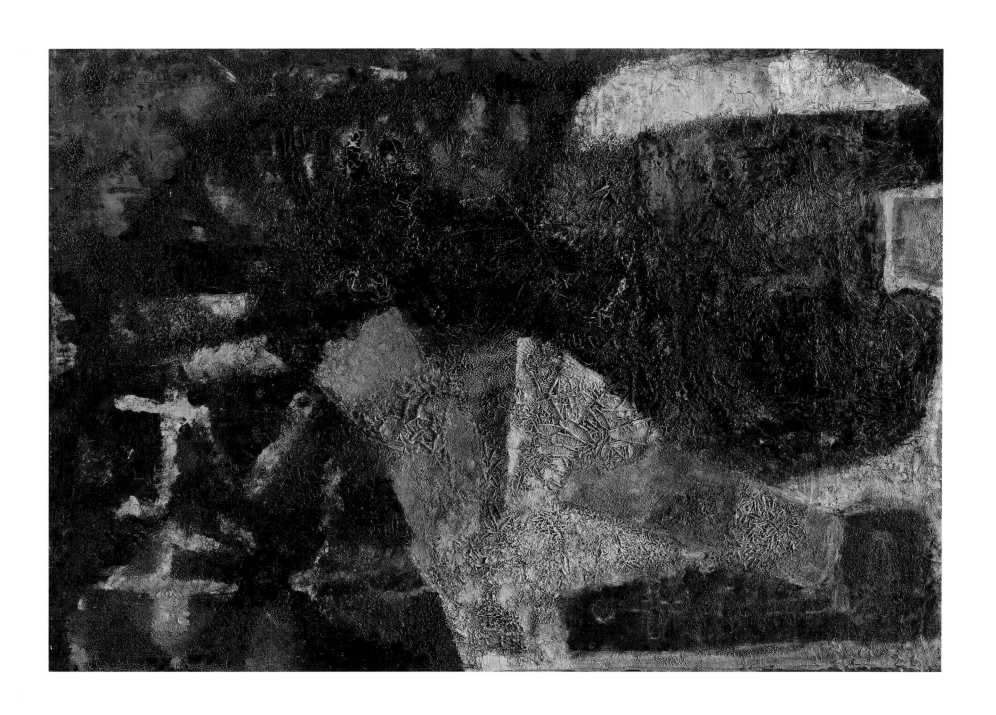

歐陽文苑
作品A
油彩 畫布

Oyan Wenyung
Work A
Oil on canvas
53x73cm,1986

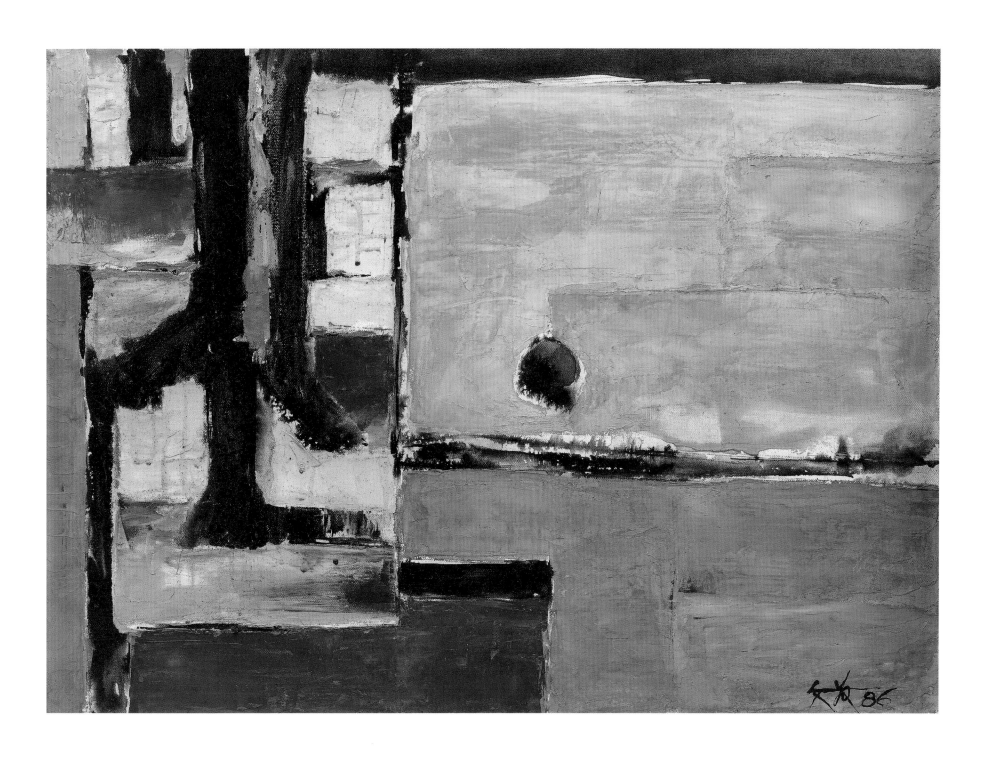

歐陽文苑
作品B
油彩 畫布

Oyan Wenyung
Work B
Oil on canvas
53x73cm,1986

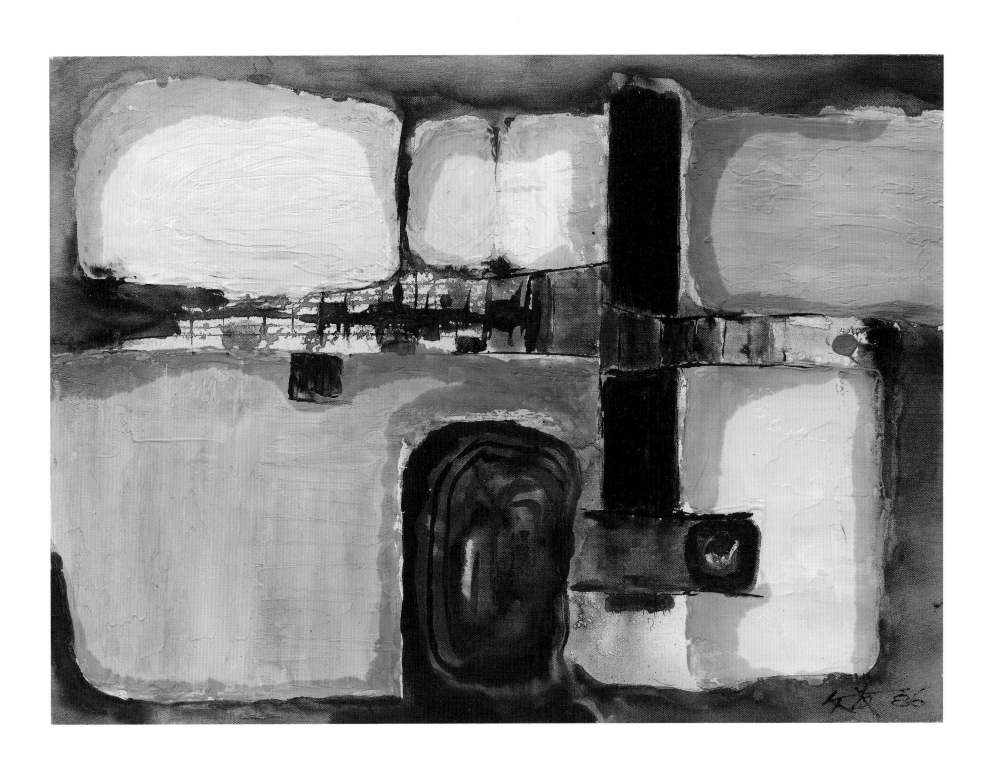

歐陽文苑
作品C
油彩 畫布

Oyan Wenyung
Work C
Oil on canvas
53x65cm,1986

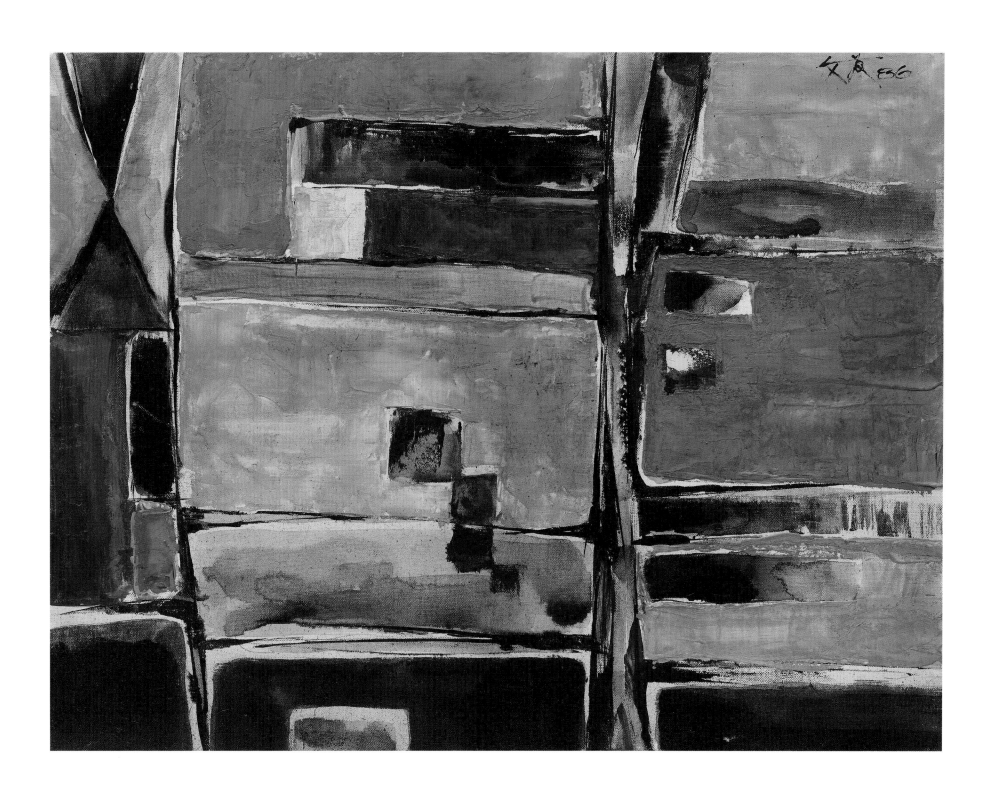

歐陽文苑
作品D
油彩 畫布

Oyan Wenyung
Work D
Oil on canvas
50x65.5cm,1986

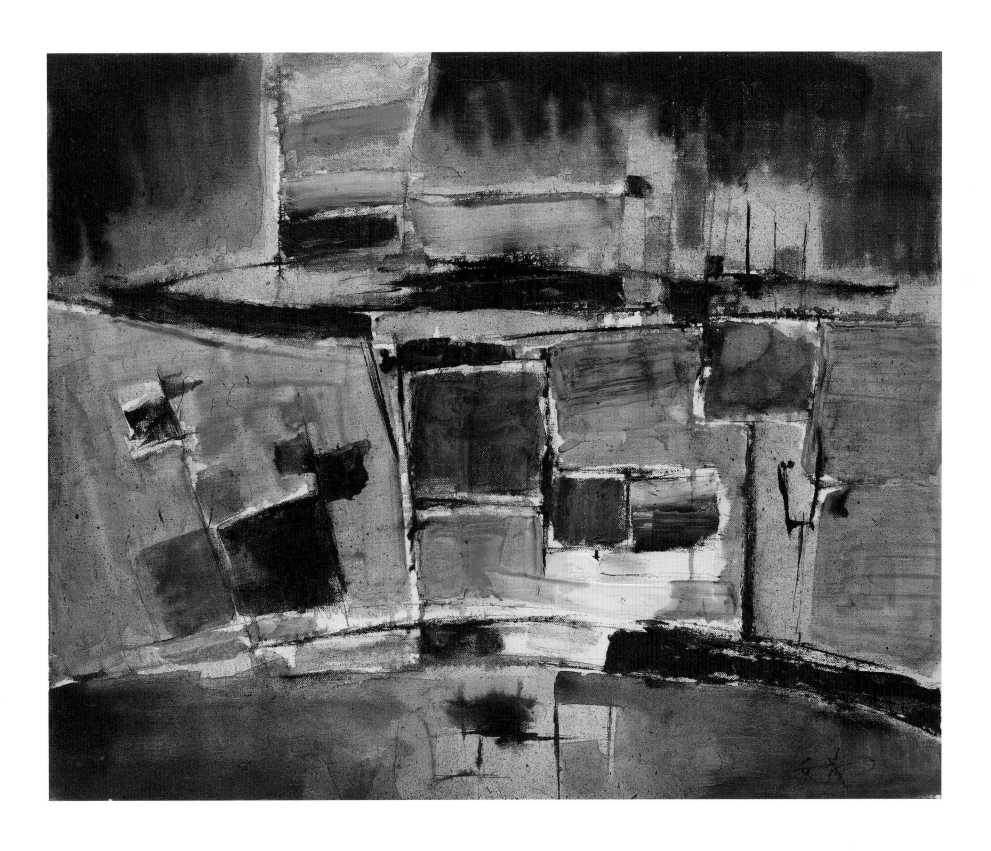

吳昊
繁花
油彩 畫布

Wu Hao
Bloom
Oil on canvas
35x27cm,1995

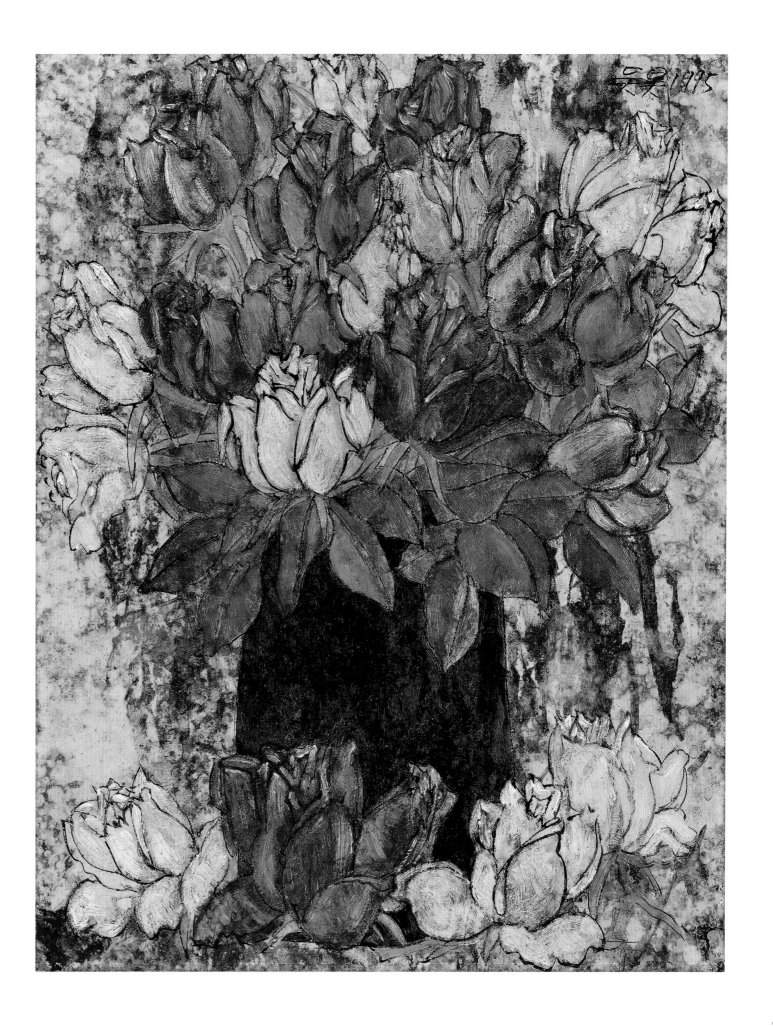

吳昊
舞
油彩 畫布

Wu Hao
Dance
Oil on canvas
100x80cm,1981

吳昊
捧花女孩
油彩 畫布

Wu Hao
A girl holds a bouquet
Oil on canvas
91x60.5cm,1998

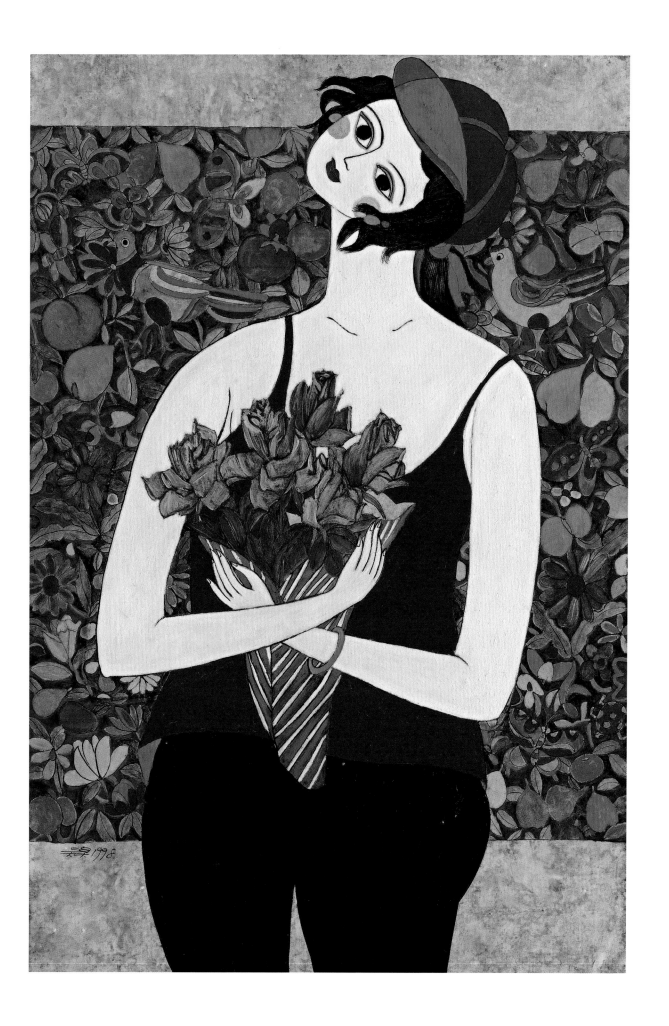

霍剛
無題
蠟筆 紙

Ho Kan
Untitled
Crayon on paper
25.5 x35cm,1955

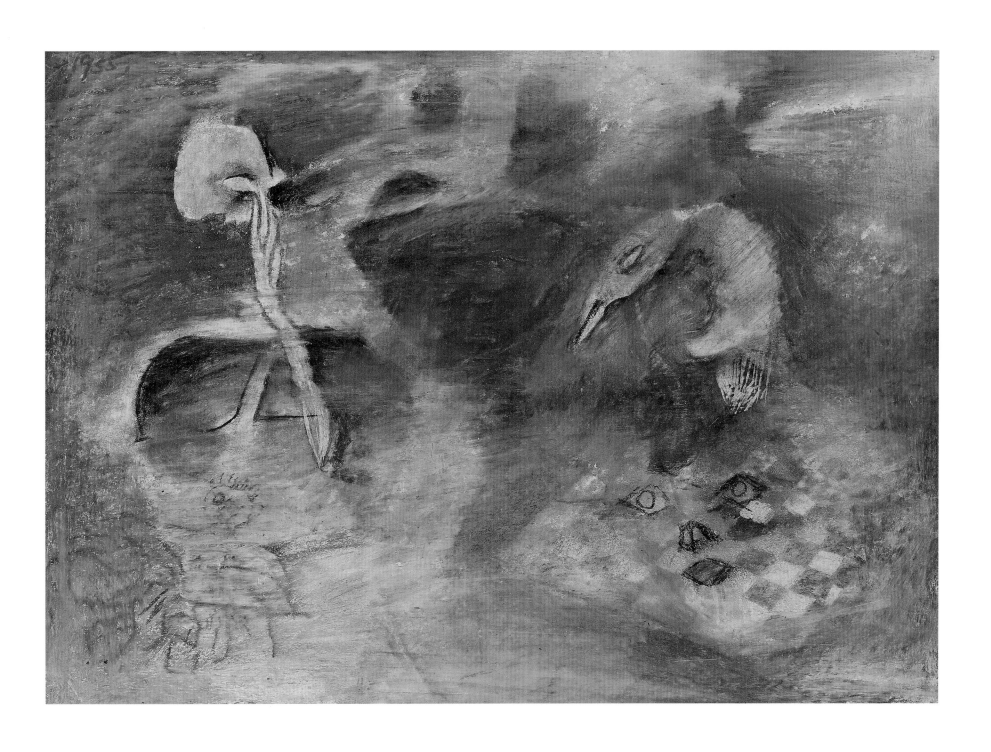

霍剛
無題
油彩 畫布

Ho Kan
Untitled
Oil on canvas
80x100cm,2007

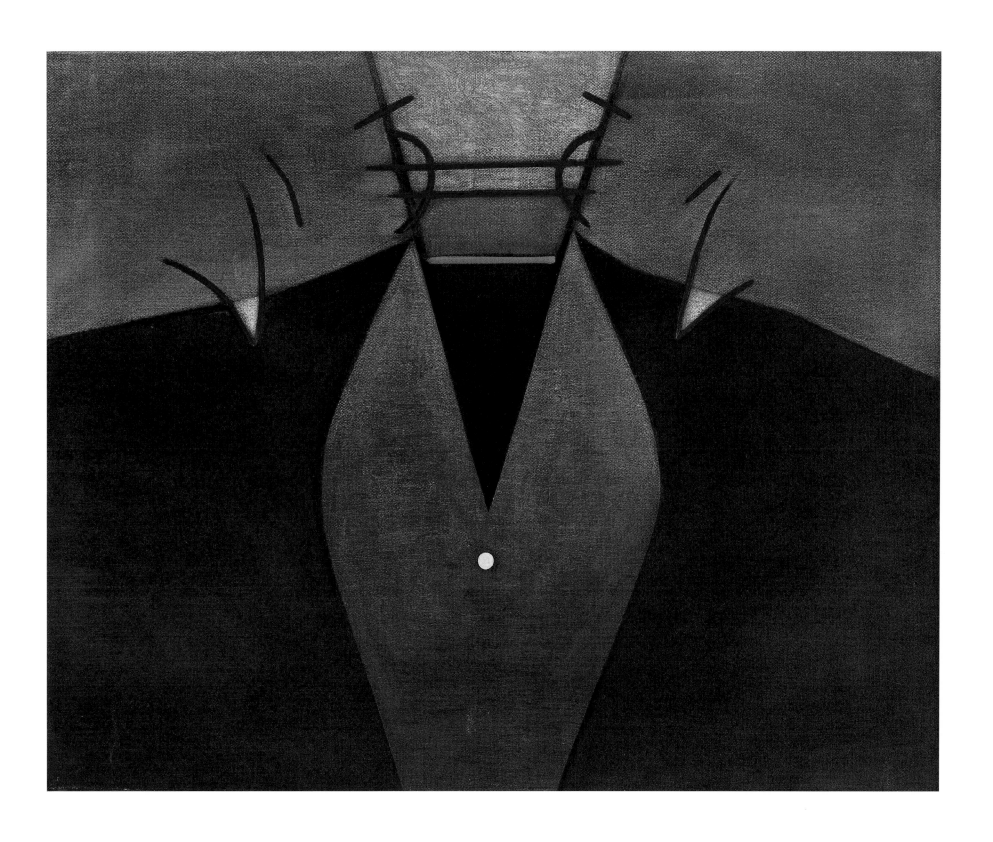

霍剛
無題
油彩 畫布

Ho Kan
Untitled
Oil on canvas
60x70cm,1967

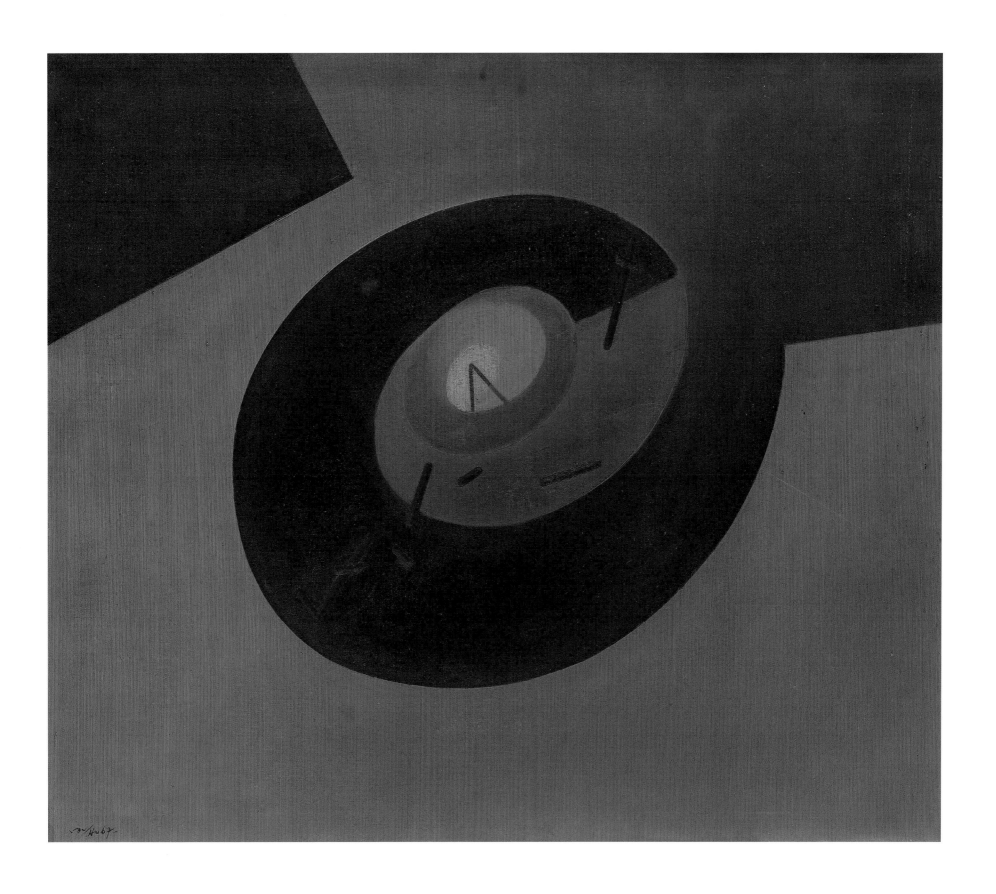

霍剛
無題
油彩 畫布

Ho Kan
Untitled
Oil on canvas
100x100cm,1970

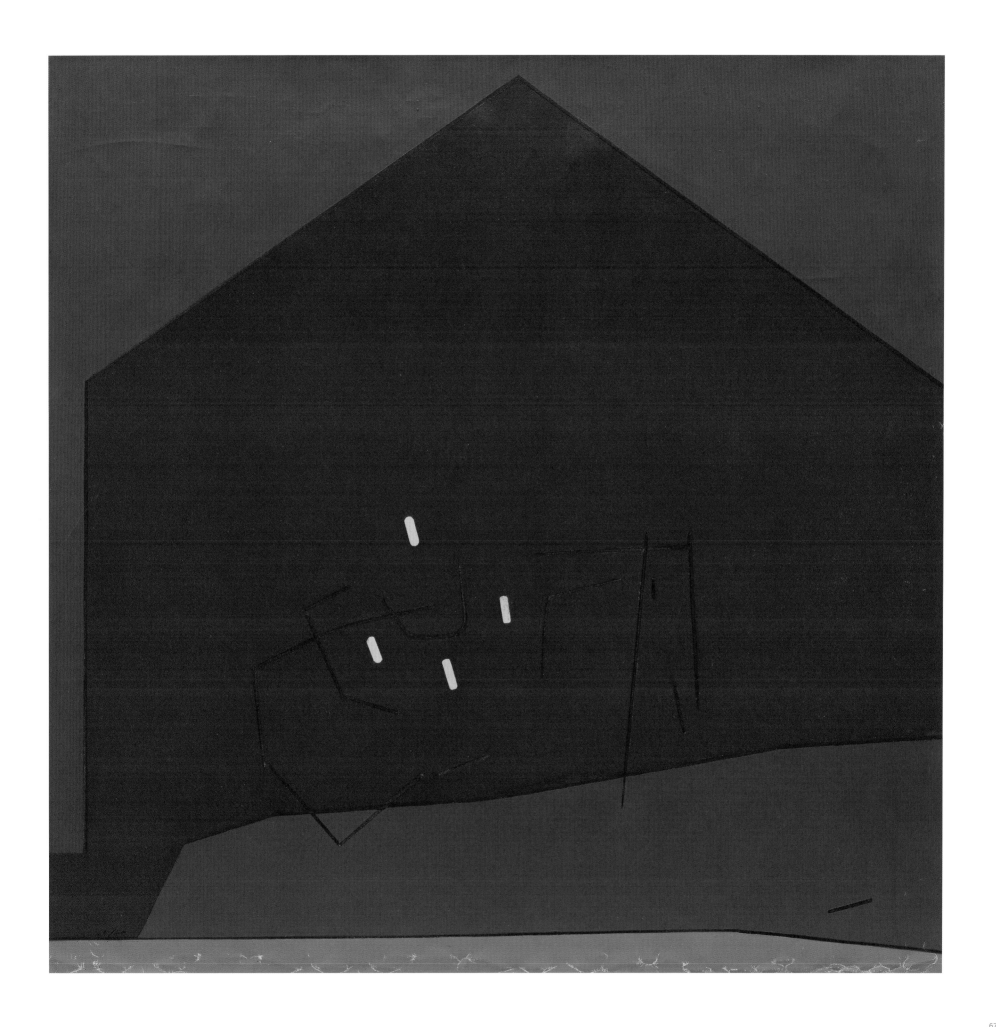

霍剛
無題
油彩 畫布

Ho Kan
Untitled
Oil on canvas
70x60cm, 1972

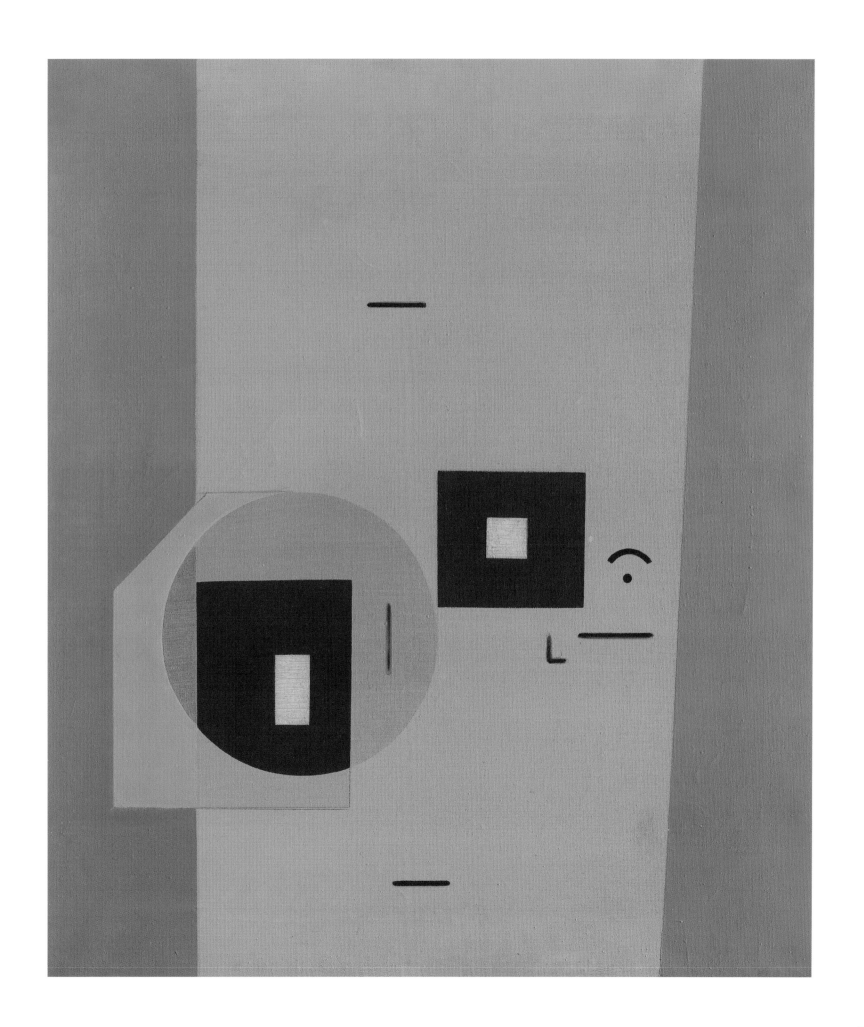

夏陽
拾穗
油彩 畫布

Hsia Yan
Gleaners
Oil on canvas
130x193cm,1998

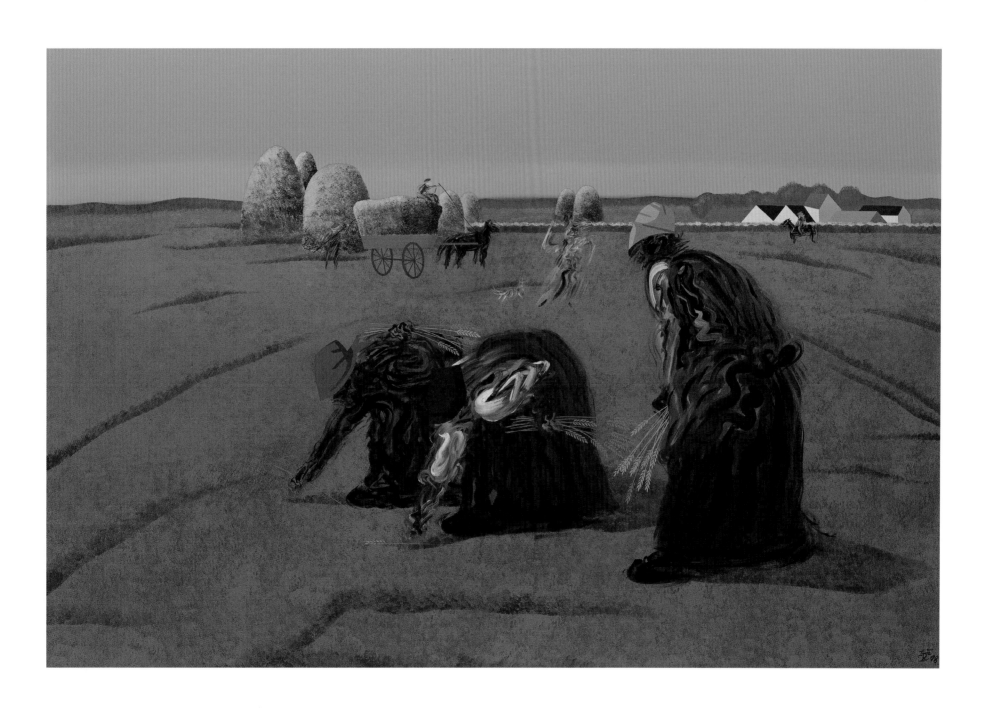

夏陽
中國拳術
壓克力彩 紙

Hsia Yan
Chinese boxing
Acrylic on paper
25x37cm,1965

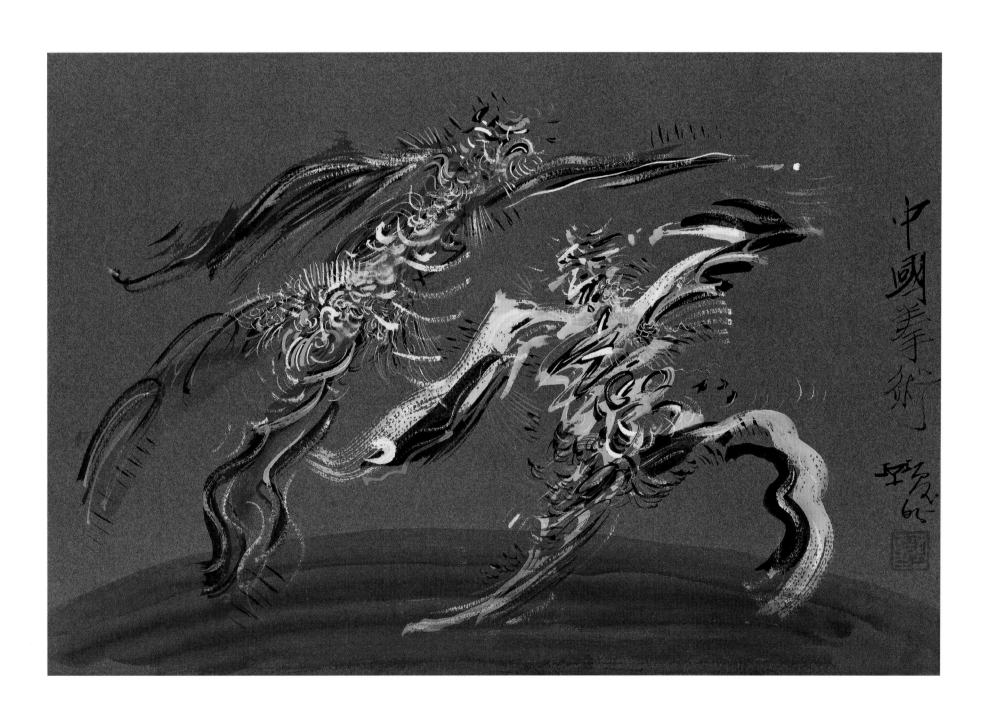

中國拳術

夏陽
獅子啣劍
壓克力彩 紙

Hsia Yan
Sword in Lion's Mouth
Acrylic on paper
46x46cm,1991

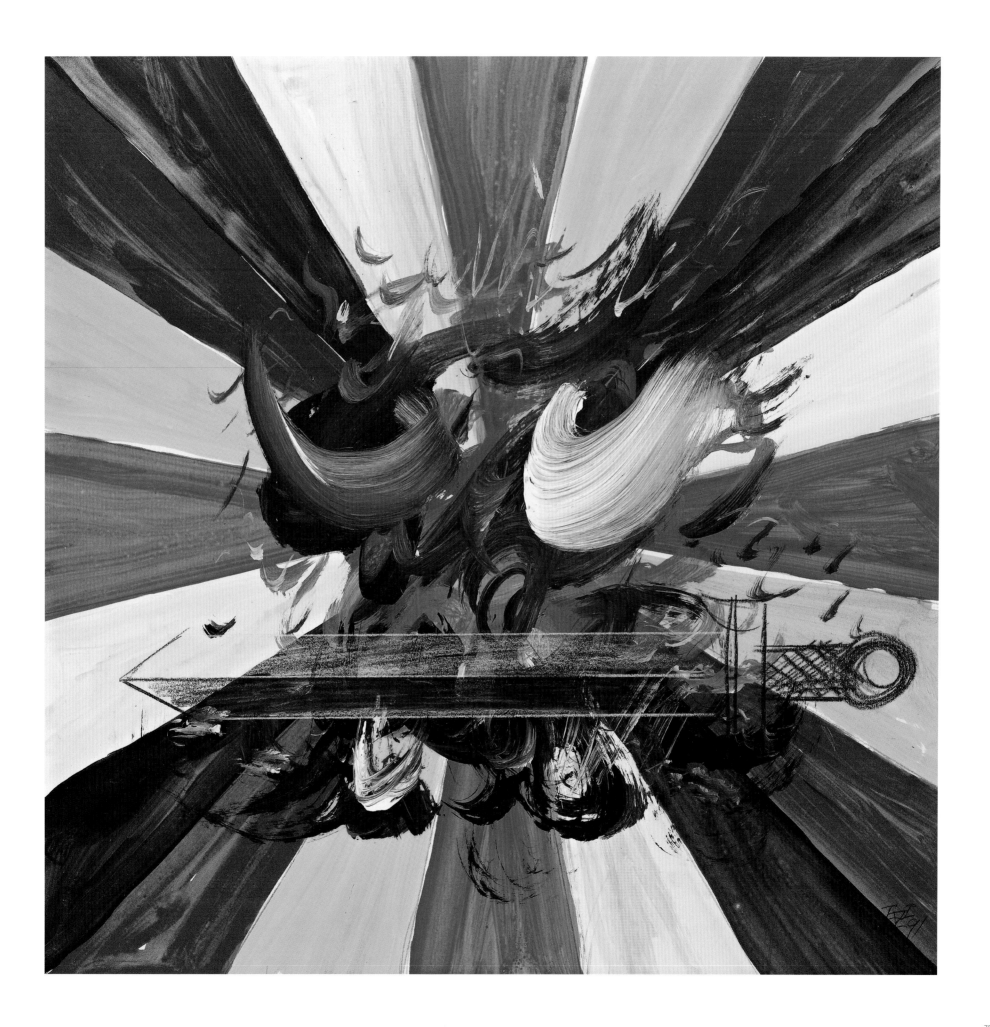

夏陽
休息的士兵
水墨 紙

Hsia Yan
A resting soldier
Ink on paper
61x46cm,1990

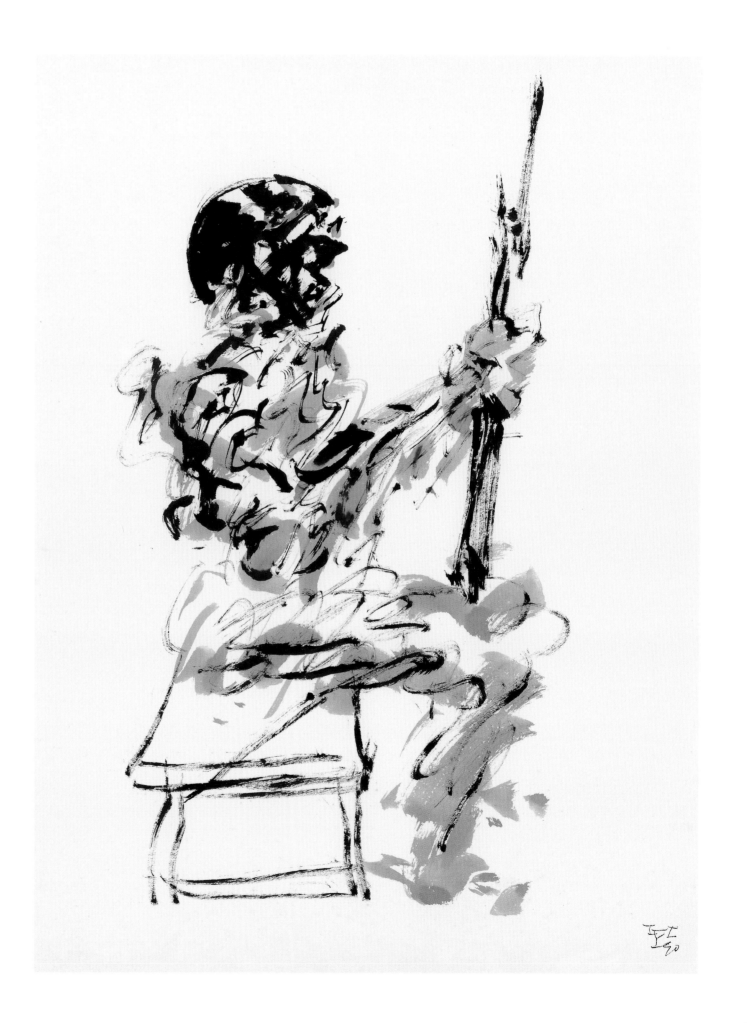

蕭勤
無題
彩墨 紙

Hsiao Chin
Untitled
Colored Ink on paper
57x40cm,1960

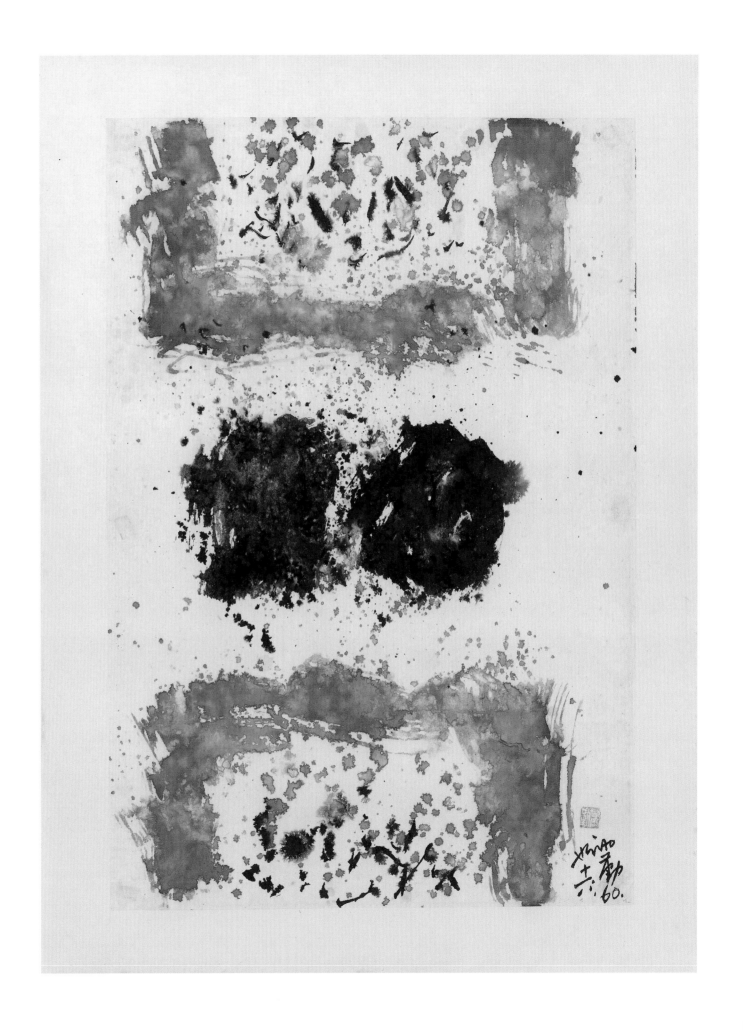

萧勤
繪畫-CC
油彩 畫布

Hsiao Chin
PITTURA-CC
Oil on canvas
70x50cm, 1959

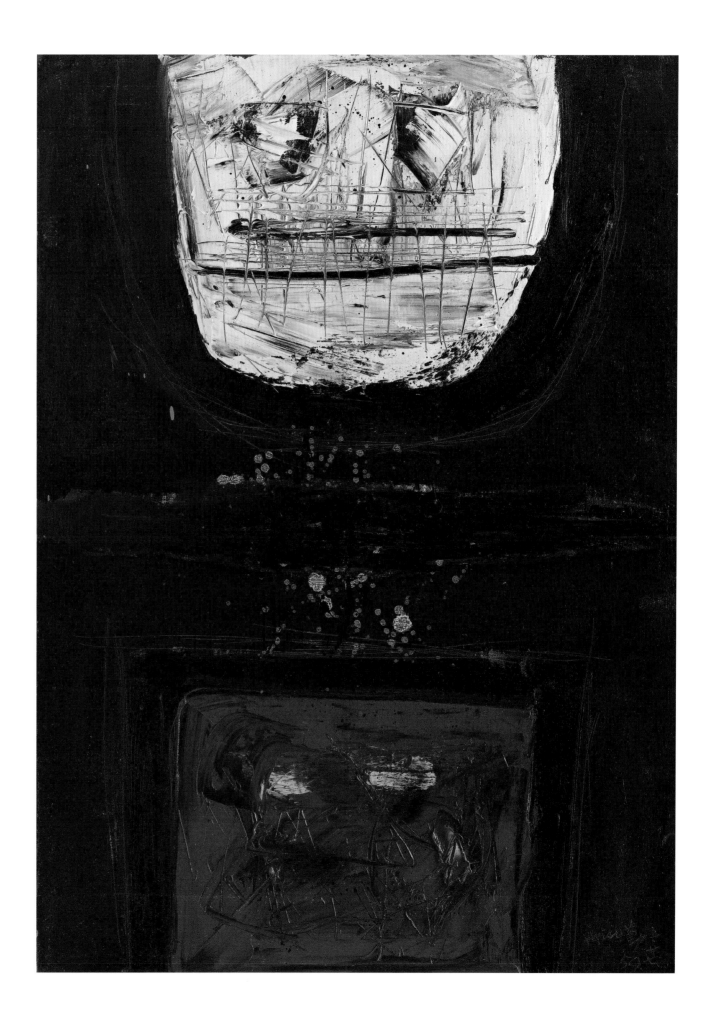

蕭勤
GB-157
油彩 畫布

Hsiao Chin
GB-157
Oil on canvas
50x70cm,1959

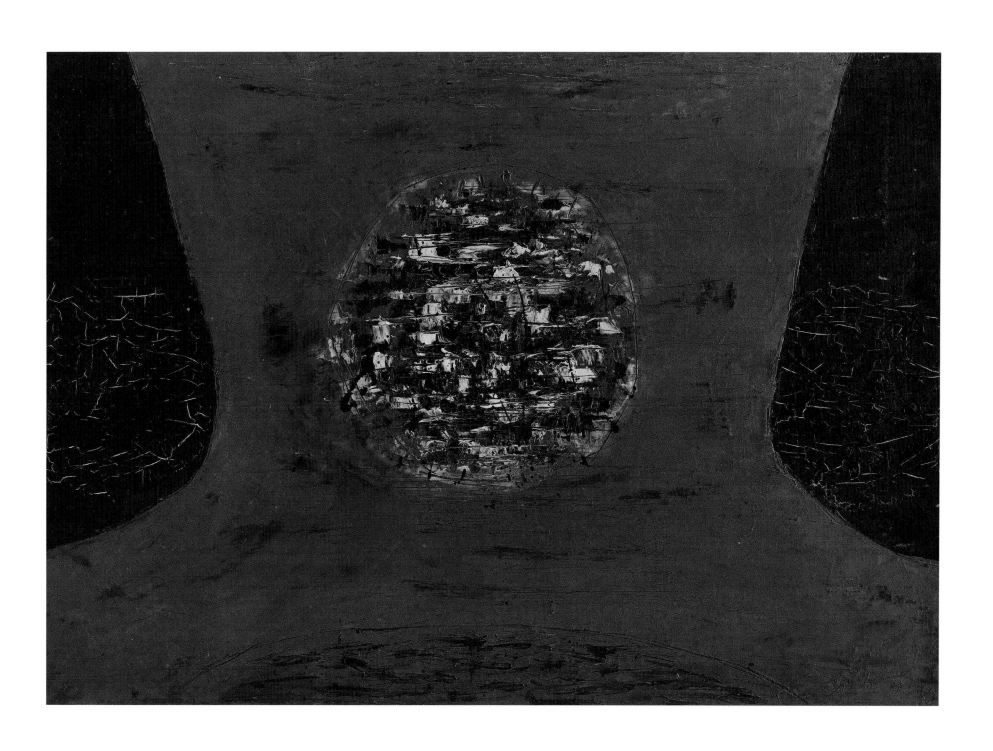

萧勤
進焉
壓克力彩 畫布

Hsiao Chin
Development
Acrylic on canvas
70x70cm, 1961

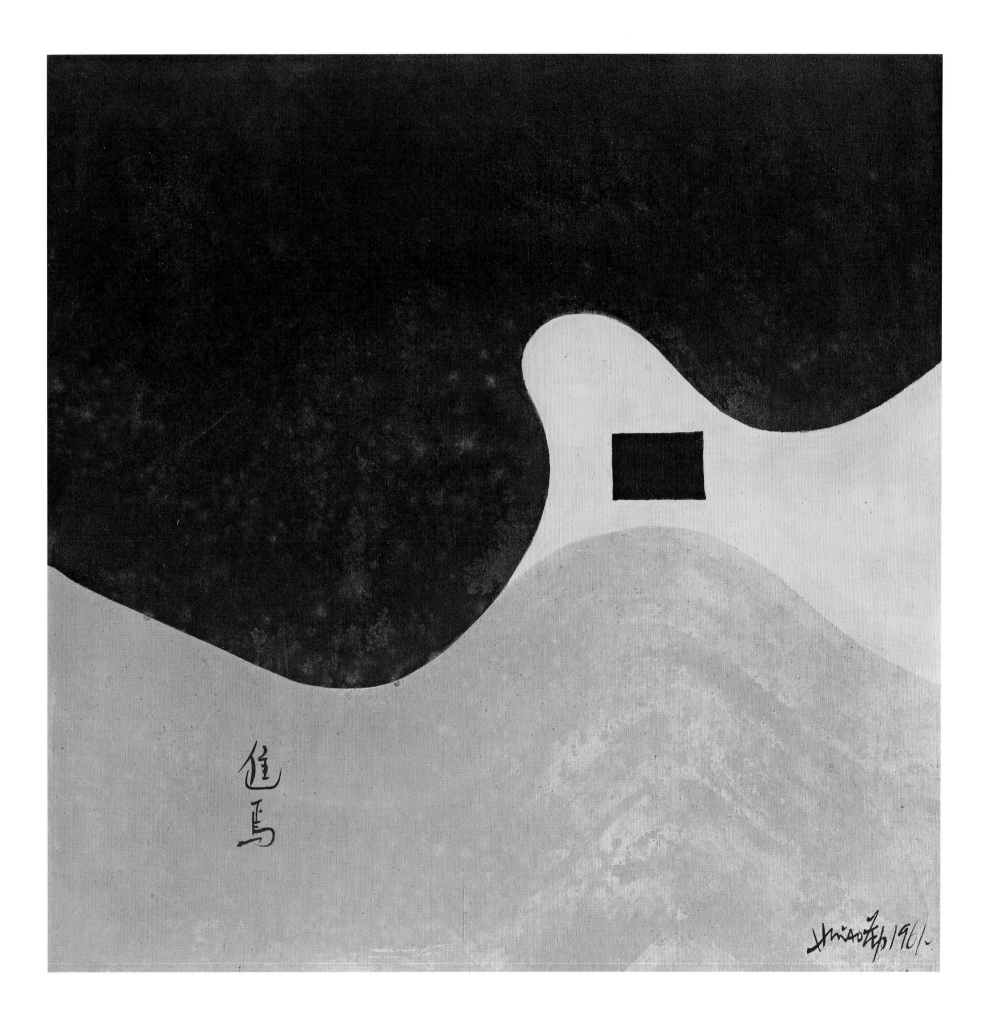

蕭勤
無題
壓克力彩 畫布

Hsiao Chin
Untitled
Acrylic on canvas
40x60cm, 1961

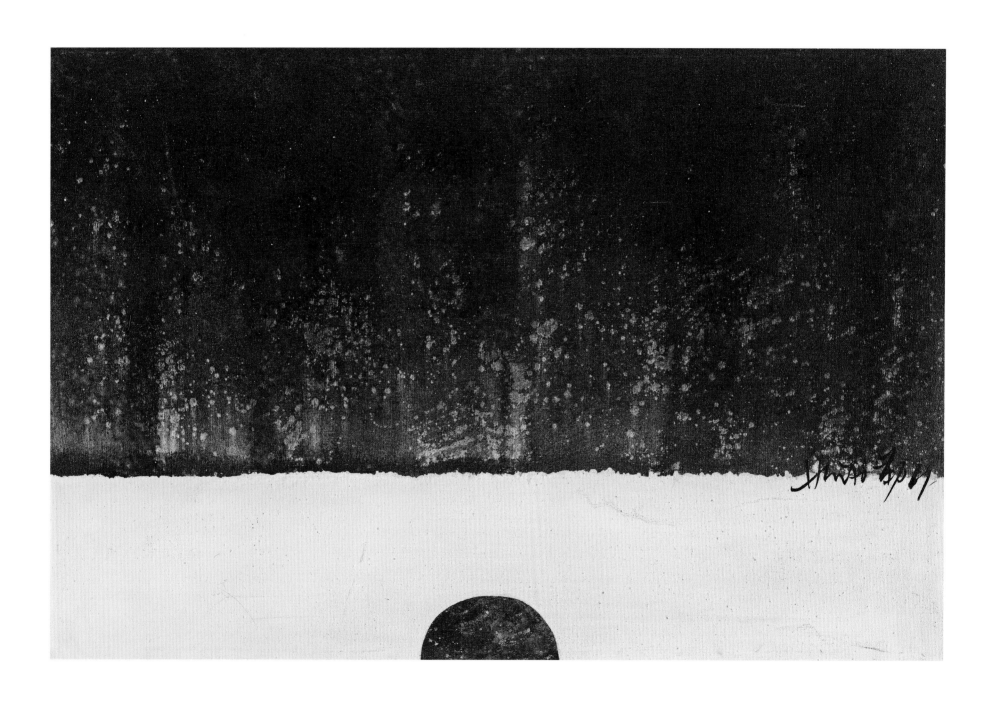

蕭勤
大限外-72
壓克力彩 畫布

Hsiao Chin
Oltre la grande soglia- 72
Acrylic on canvas
50x70cm,1995

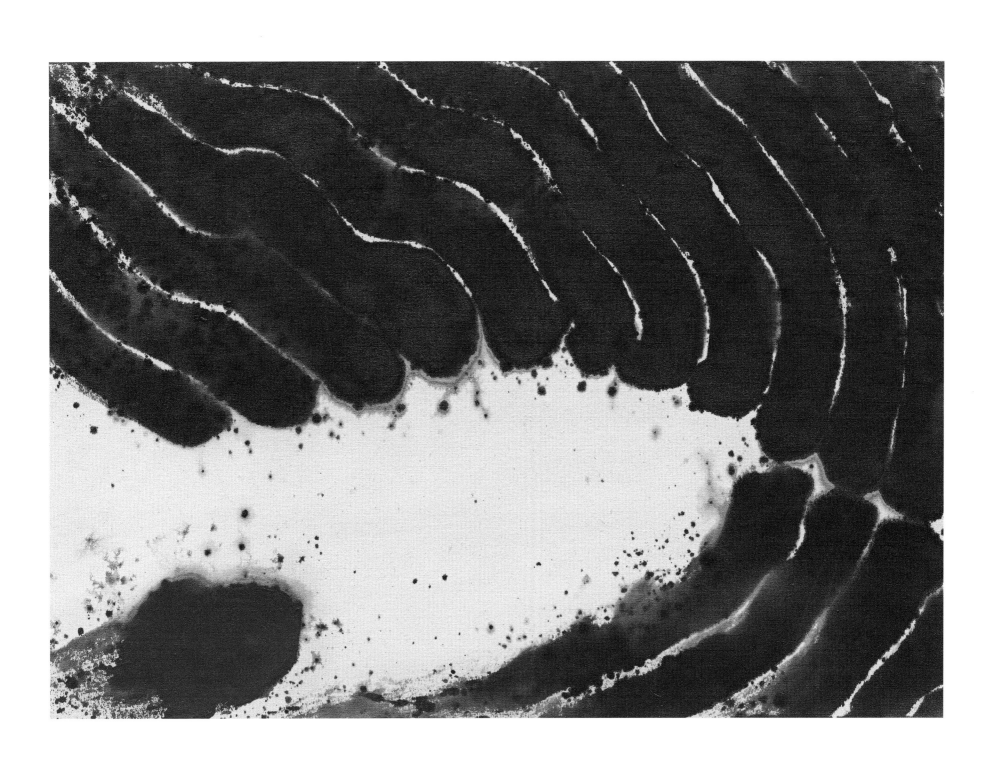

蕭明賢
無題 #0861
水墨 毛邊紙

Hsiao Minghsien
Untitled #0861
Ink on bamboo paper
25x17cm,1961

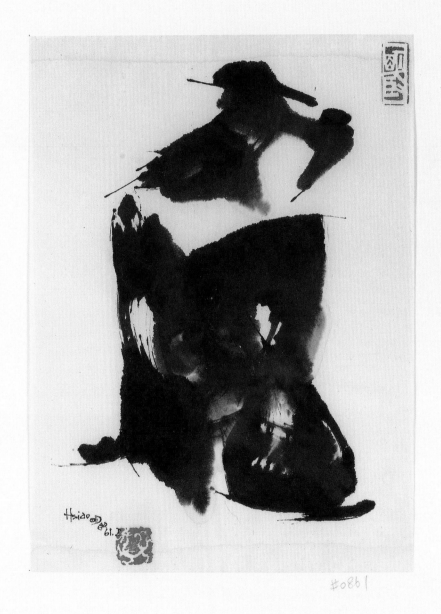

蕭明賢
構成#5707
水墨 棉紙

Hsiao Minghsien
Composition #5707
Ink on paper
120x60cm,1957

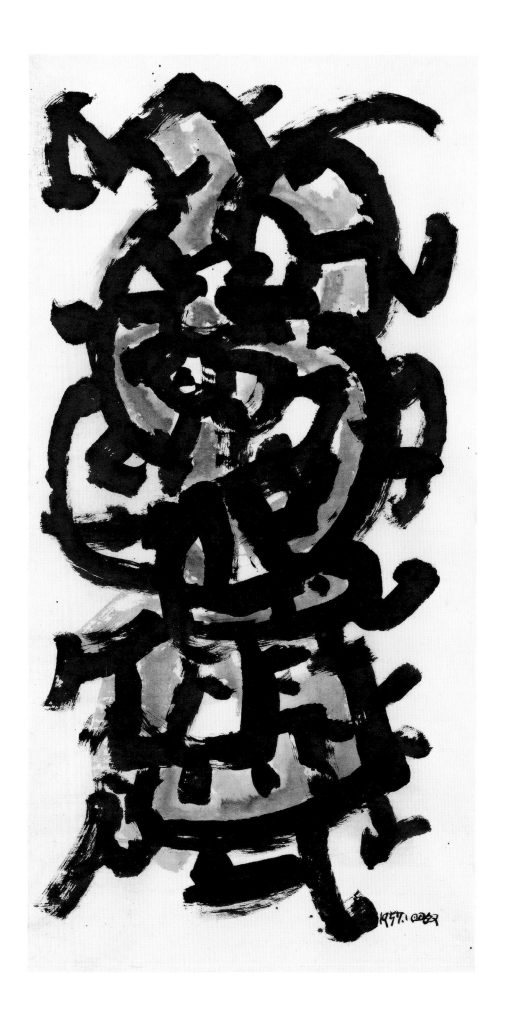

蕭明賢
時空記憶之五
混合媒材

Hsiao Minghsien
The memories of time and space- 5
Mixed media
75x45cm,2009

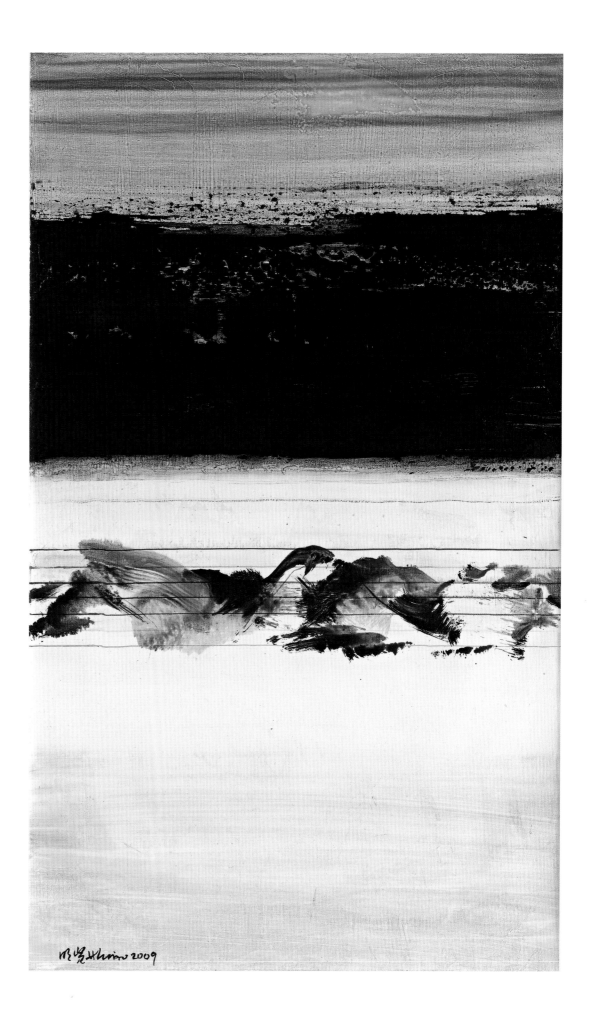

蕭明賢
時空記憶之八
混合媒材

Hsiao Minghsien
The memories of time and space- 8
Mixed media
70x55cm,2010

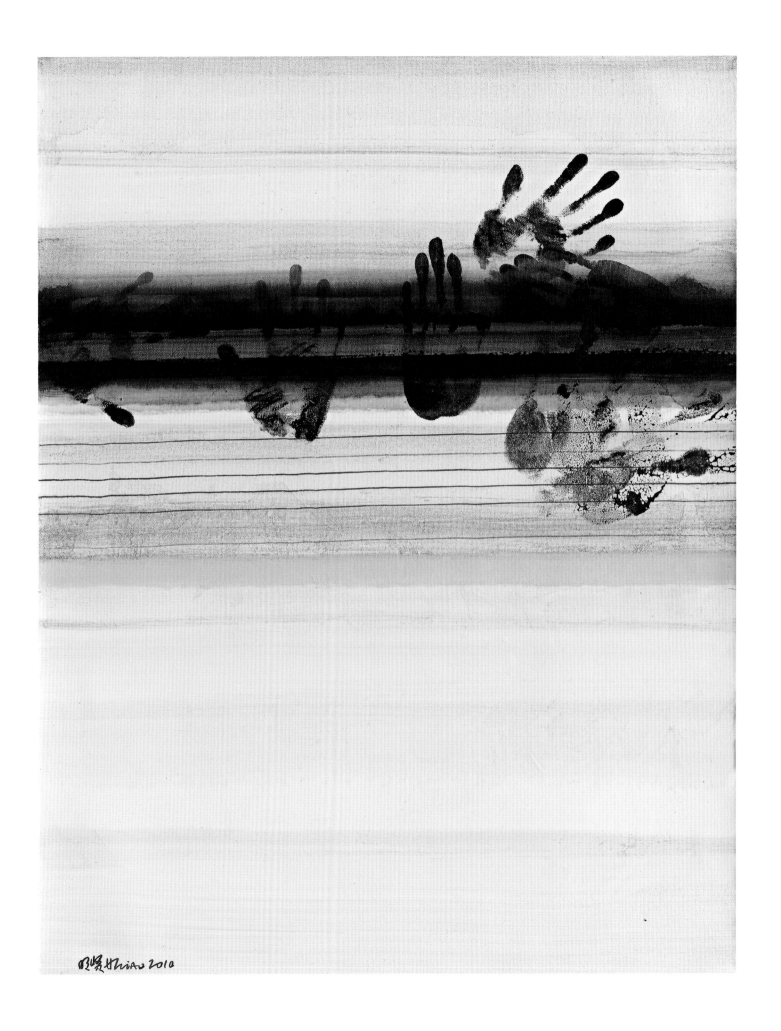

蕭明賢
黑色的絃律
油彩 畫布

Hsiao Minghsien
Black Melody
Oil on canvas
80x120cm,1996

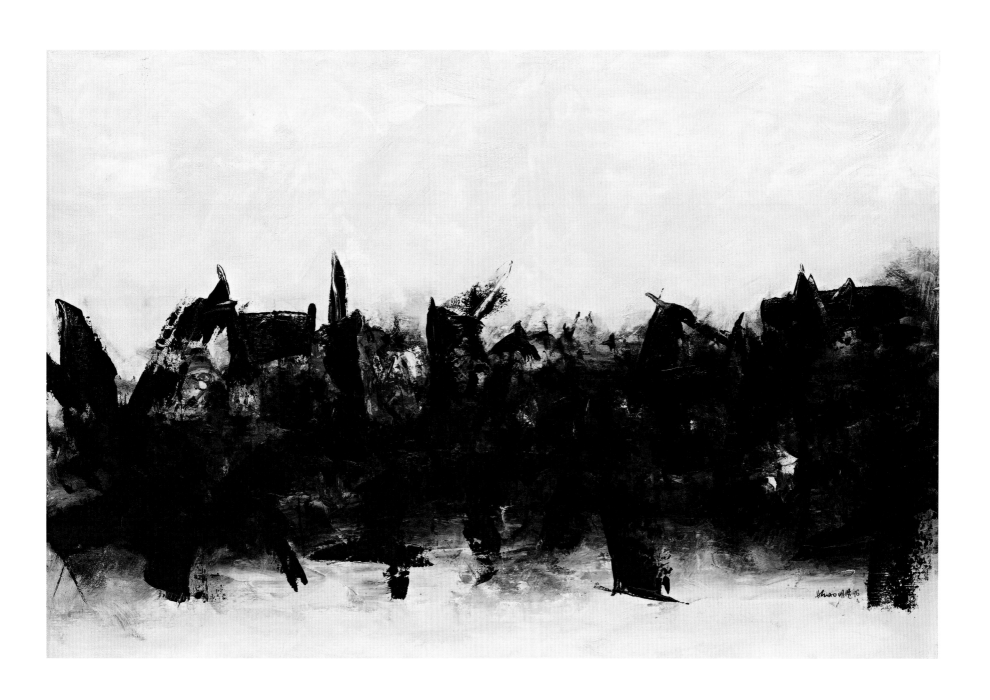

藝術家年表暨展歷
Artists Chronology

李元佳

1929　出生於中國廣西省盧山附近的許村農家，是為長子。

1948　幼年未受過教育，此時終於能在專為蔣介石軍眷開設的學校裡就讀。

1949　國民黨在與毛澤東領導的共產黨軍隊交戰失利之後，撤退到台灣。李也隨著軍隊撤退，並和專門學校的其他學生一起抵達台灣。

1951　進入省立台北師範學校（現今為「國立台北教育大學」）藝術教育系接受師資培訓，並在這兒結識到同樣從大陸撤退來台的同學蕭勤與霍剛。

1952　由於不滿學校裡教授中國藝術和美學時的保守作風，李元佳、蕭勤、霍剛等人轉而投入開設私塾的藝術家李仲生門下——李仲生對於當時許多台灣年輕藝術家有著決定性的影響與啟蒙。曾在日本留過學的李仲生，熟諳歐洲畫以及傳統中國近代繪畫的技巧。他不僅強調繪畫時手、心和眼睛協調發展的重要性，就在此時，李元佳創作出第一幅抽象作品。

1955　自省立台北師範學校畢業後，李入伍受軍事訓練，因此學習到數學和電機工程的知識。

　　　後來，他利用數學方程式畫了些小品，卻毫無數理邏輯而言，看起來就像是私人（但無法解釋）的編碼意義。

1956　與蕭勤、霍剛、夏陽、吳昊、陳道明、蕭明賢、歐陽文苑（全都曾經師承李仲生）聯手成立了東方畫會。東方畫會所創作的畫作，被視為中國近代最早期的抽象作品。

　　　對於自己在1956至1958年間所描繪的素描和水彩畫，李元佳後來是這麼形容的：「我當時受到中國哲學家老子思想以及中國書法的影響；至於在顏色上，我試著要重現中國瓷器與古代洞窟壁畫的特殊質感。」

1957　和東方畫會應邀參加巴西第四屆聖保羅雙年展（4th São Paulo Bienal）。

1959　根據李元佳自己的說法，他在此時萌生了「點」的想法：「1959年間，我的第一幅畫是白色正方形畫布上有個很小的黑點，再簡單也不過了。」

1961　蕭勤長期旅歐、經常向台灣藝術家朋友與報社回傳當地最新藝術動態，如今在米蘭定居。

　　　他在那裡與義大利畫家安東尼奧．卡爾代拉拉（Antonio Calderara）和日籍雕塑家吾妻兼治郎（Kengiro Azuma）聯手發起了「龐圖運動（Il Punto）」。

　　　蕭勤邀請東方畫會成員前往米蘭加入他們的行列，有些成員應邀前往，李元佳就是其中一位。後來，西班牙、法國與荷蘭藝術家也都紛紛響應了這項運動。不僅如此，義大利藝術家盧西奧．封塔那（Lucio Fontana）和皮埃羅．曼佐尼（Piero Manzoni）也與「龐圖運動」有密切關連。

1962　李於1962年底或1963年初抵達義大利。短暫停留後，便前往波隆那（Bologna）待了下來。波隆那的家具設計師和藝術守護神迪諾．蓋維那（Dino Gavina）有段時間非常欣賞李元佳的作品，於是幫助他順利申請通過義大利移民，順利定居當地。此外，蓋維那還將其位於波隆那聖拉扎羅（San Lazzaaro）的家具廠，挪出一間工作室和臥室給李元佳使用。李元佳在聖拉扎羅居住四年，並在那裡創作出一系列的冊頁，以及大量的單點或多點黑白畫作。他有時會將細長帶子或補丁黏在畫布上，在它們上頭塗抹一層白色料，形成基本的浮雕。他作畫時只採用四種顏色——黑，紅，白以及金色，分別代表四種原始的象徵價值。

1965　應大衛　門德拉（David Medalla）和保羅．基勒（Paul Keeler）的邀請赴倫敦的信號畫廊（Signals Gallery）展出，並在那裡參加了「探水深二（Soundings Two）」——實驗藝術的國際調查活動。他的盒裝浮雕版畫作品「白書」，於波隆那發行了一百份，由穆尼洛．門德斯（Murilo Mendes）撰序，裡頭提供了詳盡且關鍵的解說。

1966　基勒與安東尼．喀德爾（Anthony de Kerdrel）在信號畫廊舉辦了「3+1聯展」，李元佳、蕭勤、霍剛、與義大利藝術家碧卓（Pia Pizzo）均受邀參展。李受到門德拉的委託，運用「點」製作出一幅大型浮雕牆，專門為了赴倫敦參展之用，但隨後作品卻不見了。

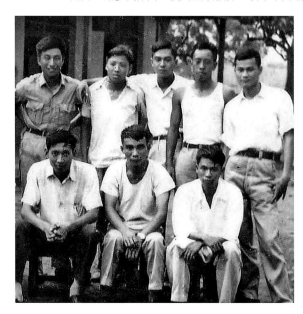

東方八大響馬　前排左起：陳道明 李元佳 夏陽　後排左起：歐陽文苑 霍剛 蕭勤 吳昊 蕭明賢
The Eight Highwaymen　Front row, from left, Chen Taoming,Li Yuanchia,Hsia Yan. Back row, from left, Oyan Wenyung, Ho Kan, Hsiao Chin, Hsiao Minghsien

1967	在海德公園的「演説者之角（Speakers' Corner）」展出「擁有與失去（All & Nothing Show）」。

1967　在海德公園的「演説者之角（Speakers' Corner）」展出「擁有與失去（All & Nothing Show）」。
此外，透過大衛　門德拉的推介，尼可拉斯·羅格斯戴爾（Nicholas Logsdail）邀請李到剛開幕的　森畫廊（Lisson Gallery）參展，也開啟了李與畫廊之間未來的合作。
他的第一場展出「宇宙點（Cosmic Point）」便是　森畫廊進行的。伴隨這次的首展，李元佳特有的小型四方目錄也首度出現。目錄裡除了放照片之外，還有一頁全白頁面，
上頭出現四個〈複製〉點；此外目錄裡還附上李的詩作，以及大衛　門德拉特別寫給李的詩和散文〈沈思〉。

1968　離開倫敦搬到坎伯蘭（Cumberland），定居在布思比（Boothby），並和朋友尼克．沙耶（Nick Sawyer）和尼克繼父威爾弗雷德．羅伯茨（Wilfred Roberts）住在一間大房子
裡。十月間，他在這間工作室舉辦了新作品的展覽。此時，他開始對易於操控的參與式結構愈來愈感興趣，並發明了可移動的磁性點，搭配圖釘後，可以放在房間牆上的任何
地方，形成各種構圖：「如果你問我，我今後的藝術走向是什麼？我會説：『玩具藝術（Toyart）』。這表示説，我的作品看起來就像『玩具』——適合每個人，老少咸宜。」
李的第二場展出「宇宙複製（Cosmic Multiples）」在里森畫廊揭幕，其中一件作品「宇宙磁性複製（Cosmagnetic Multiple）」，利用大量生產的金屬面板搭配紅、白、金、
黑四個不同顏色的磁點。

1969　「金色的月亮（Golden Moon Show）」在里森畫廊展出，這是李元佳在此處的最後一次展覽（適逢阿波羅１１號登陸月球之旅）。這次裝置藝術展出由三個截然不同的場景
構成，分別是：「月球上的人＝星星上的人」、「生活站」以及「宇宙等於一」。

1970　李元佳為白金漢郡的「小米森登節（Little Missenden Festival）」創作了一件參與式的環境藝術作品。

1971　參與了由魯伯特．理雅各（Rupert Legge）和馬克．鮑爾瓊斯（Mark Powell-Jones）策展的「參與藝術的先驅（Pioneers of Participation Art）」，在牛津現代藝術博物館
（Museum of Modern Art in Oxford）展出。同樣受邀參展藝術家還包括：利吉亞．克拉克（Lygia Clark）、約翰．杜格（John Dugger）、大衛　門德拉以及格雷姆．史帝文
斯（Graham Stevens）。

1972~1982　向畫家温尼菲．尼可森（Winifred Nicholson）買下哈德良長城（Hadrian's Wall）邊的一間破舊小農舍，家住附近的尼可森後來成了他的朋友。李獨自一人搞定搬家與房子翻
修事宜之後，於1972年8月以「李元佳美術博物館（LYC Museum & Art Gallery, LYC）」的名義對外開張。

1983　ＬＹＣ倒閉，李與「北方藝術」等公家藝術撥款機構的關係也就隨之終止。這樣的原因，加上他長久以來為了ＬＹＣ沒放過假，讓他滿心想去外地旅行（十年間，儘管朋友不
斷地敦促，他卻從不放假），於是他決定出售大部分的建築物。

1986~1987　李元佳去了一趟或二趟西班牙探訪朋友，停留了三個月。

1989　儘管官司纏身，李仍持續藝術創作，並和其他二十三位藝術家受邀參加由拉希德．阿蘭（Rasheed Araeen）策展的「另一個故事：戰後英國的亞非藝術家（The Other Story:
Afro-Asian Artists in Postwar Britain）」，並帶來了一些新的創作。【1989和1990年間，分別在倫敦海沃藝廊（Hayward Gallery）、伍爾弗漢普頓畫廊（Wolverhampton Art
Gallery）和曼徹斯特市立美術館（Manchester City Art Gallery）展出。】

1991~1994　李元佳進行多種領域的創作：在攝影方面，他不僅實驗層疊的技法（包括穿越自己的畫作和雕塑所拍下的照片），也實驗在印出的黑白照片上著色；拍攝靜物與相機配件的組
合——利用日光或燭光的光線，背景有時在家裡，有時在花園裡，有時是當地的景色，有時則是用房子旁附屬建物裡的大型金魚水族箱做背景。

1994　11月，李元佳因腸癌死於卡萊爾（Carlisle）在伊甸園谷安養院（Eden Vale Hospice），埋葬在哈德良長城下方山谷的蘭納柯斯修道院（Lanercost Priory），並以聖公會及中
國儀式分別進行了二場告別式。

Li Yuanchia

1929 Li is born on 6 April in Hsu village, near Lu Shan, Kwangsi Province, China. He is the eldest son in a peasant family.

1948 Not having had an education as a child, Li is eventually able to study at a special school for the children of Chiang Kai-shek's officers in China.

1949 After their defeat by the Communist forces led by Mao Tse-tung, the Nationalists retreat to Taiwan. Li goes as part of this exodus and arrives in Taiwan together with the other students of special schools.

1951 Li enters the art education department of Taipei Normal College for teacher-training. He meets Hsiao Chin and Ho Kan, who are fellow students and also refugees from mainland China.

1952 Dissatisfied with the conservative and academic training in Chinese art and aesthetics prevailing in the school, Li, along with Hsiao Chin, Ho Kan and others, study with the artist and independent teacher Li Chuhshan, who exerts a decisive, liberating influence on many young Taiwanese artists. Having studied in Japan, he is well versed in European as well as traditional Chinese modern painting. He emphasizes the importance of developing a co-ordination between hand, mind and eye through drawing. Li makes his first abstract work.

1955 After graduating from Taipei Normal College, Li does military training in the course of which he learns mathematics and electrical engineering. Later he uses mathematical equations to little paintings, disregarding mathematical logic in favour of what appears to be a personal (but unexplained) coded meaning.

1956 With Hsiao Chin, Ho Kan, Hsia Yan, Wu Hao, Chen Taoming, Hsiao Minghsien and Oyan Wenyuan (all ex-students of Li Chuhshan), Li establishes of the Ton Fon Painting Group. Ton Fon produces what are thought to be the first abstract works in modern China. Of the drawings and watercolours he produced between 1956 and 1958, Li wrote later, 'I was influenced by the basic ideas of the Chinese philosopher Lao Tzu and by Chinese calligraphy; in the colours I tried to recapture the special quality of Chinese porcelain and ancient cave paintings.'

1957 Li is invited, with Ton Fon, to exhibit and the 4th São Paulo Bienal, Brazil.

1959 According to his own account, Li originates the idea of the Point. 'In 1959 my first painting was a tiny black dot on a white square of canvas-nothing could be simple than that.'

1961 Hsiao Chin, who has been travelling extensively in Europe and sending back reports of new developments in art to artist friends and newspapers in Taiwan, settles in Milan. There he established Il Punto (The Point) group with the Italian painter Antonio Calderara and the Japanese sculptor Kengiro Azuma. Hsiao Chin invites artists from Ton Fon to join him in Milan and several (including Li) do. Later, Spanish, French and Dutch artists join the movement. The Italian artists Lucio Fontana and Piero Manzoni are also in close contact.

1962 Li arrives in Italy in late 1962 or early 1963. After a short stay he travels to Bologna and settles there. The Bolognese furniture designer and patron of the arts, Dino Gavina, has admired Li's work for some time. He helps Li to obtain the necessary paper to settle in Italy and offers him a studio and bedroom in his furniture factory at San Lazzaaro, Bologna. Li remains in San Lazzaro for four years. There he produces his series of album leaf, and numerous paintings in which he evolves the pictorial form of the tiny Point, or Points, in a monochrome field. He sometimes glues small strips or patches to the canvas, overpainted white so that they form very low reliefs of raised panels. He restricts his palette to four colours - black, red, white and gold - to each of which he gives a primordial symbolic value.

1965 Li is invited by David Medalla and Paul Keeler to show his work at Signals in London, where he participates in Soundings Two, an international survey of experimental art. The White Book, a boxed set of embossed prints, is published in Bologna in an edition of 100 copies, with a preface by Murilo Mendes and an explanatory key provided by the artist.

1966	Keeler and Anthony de Kerdrel organize at Signals 3+1, an exhibition which includes Li, Hsiao Chin, Ho Kan, and the Italian artist Pia Pizzo. Li travels to London and is commissioned by Medalla to execute a large wall relief incorporating points especially for the show which was subsequently lost.

1967	Li stages the All & Nothing Show at Speakers' Corner, Hyde Park. As a result of recommendations from David Medalla, Li is invited by Nicholas Logsdail to exhibit at the new Lisson Gallery and he forms an association with the gallery.

His first show Cosmic Point opens at the Lisson. To accompany this show, the first of Li's distinctive small square catalogues appear. As well as photographs, it contains four 'multiples' with a single Point set on a white page, poems by Li, and a poem and prose 'mediation' dedicated to Li by David Medalla.

1968	Li leaves London and moves to Cumberland. He settles at Boothby, in a large room made available by his friend Nick Sawyer and Nick's step-father Wilfred Roberts. In October he holds a studio exhibition of his new work there. He becomes increasingly interested in manipulable, participatory structures. He invents the moveable, magnetic point, which, with the aid of a drawing pin, can be placed anywhere on the walls of a room in any composition; 'If you ask me where my art is going after today, my answer is "Toyart", which means: my works seem like "toy" – good for everyone, from children to old men (women)'. Li's second show Cosmic Multiples opens at the Lisson Gallery, (it features the Cosmagnetic Multiple, a mass-produced metal panel and four magnetic points, red, white, gold and black.

1969	Golden Moon Show opens at the Lisson Gallery, Li's last exhibition there (it coincides with the voyage of Apollo 11 to the moon). The installation consists the three distinct environments: 'Man on the moon = men in the stars', 'Life station' and 'Universe = one'.

1970	Li builds an environmental and participatory work for the Little Missenden Festival in Buckinghamshire.

1971	Li participates in Pioneers of Participation Art curated by Rupert Legge and Mark Powell-Jones at the Museum of Modern Art in Oxford. Other artists included are Lygia Clark, John Dugger, David Medalla and Graham Stevens.

1972-1982 Li buys a small, run-down farmhouse at Banks on Hadrian's Wall from the painter Winifred Nicholson who lives nearby and with whom he becomes friends. After moving in and refurbishing the building single-handedly, he opens it to the public in August 1972 as the LYC Museum & Art Gallery (LYC).

1983	With the closure of LYC, Li's relationship with official arts funding bodies such as Northern Arts ceases. This, and his desire to travel after being permanently tied to LYC for ten years (in spite of the urgings of friends, he never took a holiday), make him decide to put the majority of the building up for sale.

1986-1987 Li makes one or two trips to visit friends and spends three months in Spain.

1989	Despite his trials, Li's art work continues to develop. He is invited to participate in The Other Story: Afro-Asian Artists in Postwar Britain, a survey show of twenty-four artists curated by Rasheed Araeen (Hayward Gallery, London; Wolverhampton Art Gallery; and Manchester City Art Gallery, 1989-1990), where he brings several strands of his work to fruition.

1991-1994 Li engages simultaneously on several strands of work. Photography: he experiments with superimposition (including 'see-through' photographs of his own paintings and sculpture), with colour-printing and hand-colouring of black and white prints; with 'still-lives' and other set-ups for the camera, both in daylight and by candle-light, in the house, in the garden, the local landscape, and a large tank of water with goldfish installed in one of the outbuildings.

1994	November, Li dies at the Eden Vale Hospice in Carlisle of intestinal cancer. He is buried at Lanercost Priory in the valley below Banks, with both an Anglican and a Chinese ceremony at the graveside.

歐陽文苑

1928　　出生於中國廣西省

1951　　入台北市安東街李仲生畫室，研習現代繪畫，展開其現代藝術的繪畫歷程

1952　　與吳昊、夏陽進駐防空洞作畫

1956　　與霍剛、吳昊、李元佳、陳道明、夏陽、蕭勤、蕭明賢等籌組創辦中國第一個現代繪畫團體 –「東方畫會」

1957　　首屆東方畫展在台北新聞大樓展出，另有西班牙14位現代畫家參展

1958　　十一月，東方畫會與西班牙及厄瓜多爾畫家台北聯展

1958~1965 參與第二屆至第九屆，「東方畫會」展於台北，台灣

2007　　歐陽文苑逝世於巴西

2012　　「藝拓荒原→東方八大響馬」，大象藝術空間館，台中，台灣

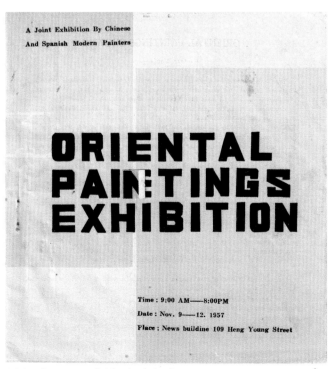

東方畫展-中國、西班牙現代畫家聯合展出_畫冊封面
ORIENTAL PAINETINGS EXHIBITION

Oyan Wenyung

1928 born in Kwangsi Province, China

1951 Oyan Wenyung attended Li Chuhshan's studio on An-tong street and studied Western paintings. This was the beginning of his dedication and devotion to modern arts

1952 Begins painting at bomb shelter along with Wu Hao and Hsia Yan

1956 With Ho Kan, Wu Hao, Li Yuanchia, Chen Taoming, Hsia Yan, Hsiao Chin, and Hsiao Minghsien , Oyan Wenyung establishes of the Ton Fon Art Group. Ton Fon produces what are thought to be the first abstract works in modern China

1957 Ton Fon Art Group held its first exhibition at Taiwan Shin Sheng Daily News Building on November 25.Had a joint exhibition both in Galleria Jardin, Barcelona, Spain and in Taipei, Taiwan

1958 Ton Fon Art Group had a joint exhibition in Taipei along with Spanish and Ecuadorian artists in November

1958~1965 Second to Ninth Ton Fon Art Group Exhibition, Taipei, Taiwan

2007 Oyan Wenyung passes away in Brazil

2012 "Exploring the Wasteland – The Eight Highwaymen of the East" , Da Xiang Art Space, Taichung, Taiwan

陳道明

1933年出生於山東濟南，八歲時開始學習傳統畫，十八歲時從大陸來台就讀於台北師範學院，並開始跟隨李仲生學習現代畫。1956年與蕭勤、霍剛、夏陽等人創辦東方畫會，積極推動台灣現代繪畫運動。五〇年代開始，陳道明專於塗鴉性強的速寫創作，是一種近乎意識流的自然抒發，而作畫不以紀錄寫實為目標，但求聊表胸中逸氣而已。

六〇年代以降，陳道明開始嘗試複合媒材實驗，意圖表達一種蒼涼掙扎的戰後情境，作品中圖像符號已被抽離為最的點、線、面元素。媒材上則結合油彩顏料及一般性銅油，在急速的交融質變過程中產生畫面豐富的肌理變化，此期畫作的色譜多屬灰褐色調，然畫表細密的皺褶、斑駁變化在強光的照耀下折射出閃爍華麗的光彩。七〇年代以前的陳道明在台灣藝壇的活動是頻繁且令人振奮的。此時期的旅歐藝術家蕭勤的策動下，東方畫會先後於西班牙、義大利及美國等地巡迴展出。此外，陳道明亦獲國內教育部之徵選先後參加巴西聖保羅雙年展、國際巴黎青年畫展及香港亞洲國際美展等，並獲得極高的榮耀獎賞。

九〇年後再度復出展出，而畫風亦顯著改變。壓克力、水彩等水性顏料的流暢性，渲染性取代了厚重濃鬱的油彩，而大片留白營造出視覺上自由瀏覽的時間性空間，呼應著藝術家年少時期學習國畫的心境，追求氣韻生動的精神理念，亦回應著作者對幼年成長的黃土高原，那開闊寬廣自然的鄉愁。

1933	出生於山東濟南
1951	隨家人來台，就讀於台北師範學院（現今國立台北教育大學）
1955	成立東方畫會，為創辦人之一
1956	參加中華民國四十五年全國書畫展，作品由教育部選購，轉送給泰國作為泰國慶憲節之賀禮，並成為泰國國立美術館典藏作品之一
1957	十一月二十五日在台北新聞大樓舉行首屆東方畫展
	西班牙巴塞隆納花園畫廊與台北同時聯展
1958	一月，西班牙克朗畫廊畫展
	二月，西班牙賽維拉畫廊畫展
	十一月，東方畫會與西班牙及厄瓜多爾畫家台北聯展
	十一月，西班牙巴塞隆納維瑞納畫廊畫展

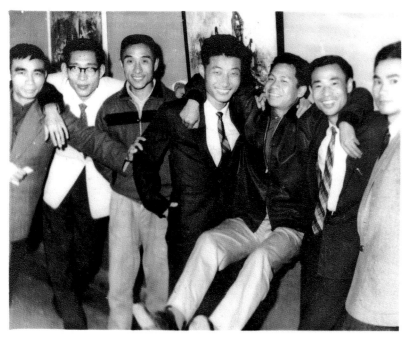

東方畫會成員
The members of Ton Fon Art Group

1959	教育部評選第一名，得以五件作品參加國際巴西聖保羅雙年畫展
	國際巴黎青年畫展，獲巴黎藝術評論家評選為最具潛力畫家
	一月，西班牙雄芝關阿那藝術家學會參展
	五月，義大利佛羅倫斯努梅諾畫廊參展
	六月，義大利米蘭市魯畫廊參展
	十月，義大利佛羅倫斯努梅諾畫廊畫展
	十一月，義大利馬賽拉塔畫廊參展
	十二月，台灣台北藝術館東方畫展
1960	一月，美國紐約米丹畫廊畫展
	二月，義大利磊格都諾格拉塔西畫廊畫展
	八月，義大利威尼斯史帝法諾畫廊畫展
	九月，義大利史都戈特聖那多爾畫廊畫展
	十月，義大利都林市布常拉畫廊畫展
	香港，亞洲國際美展銀牌獎
1961	十一月，台灣台北東方畫展
1962	義大利發拉色畫廊畫展
1965	教育部評選參加國際巴西聖保羅雙年畫展
1980	楊興生與陳道明聯展，台灣台北羅福畫廊
1981	東方畫會與五月畫會二十五週年紀念聯展，台灣台北歷史博物館
1996	作品 "兒童與馬" 作品獲台北市立美術館典藏
1997	東方畫會與五月畫會四十週年紀念聯展，台灣台中國立美術館
2012	「藝拓荒原→東方八大響馬」，大象藝術空間館，台中，台灣

Chen Taoming

Chen was born in Jinan, Shandong in 1933. He began to learn traditional art at age eight. At eighteen, he came to Taiwan from mainland China and studied in Taipei Normal School. Later he began to learn modern paintings from Li Chuhshan. In 1956, he founded Ton Fon Art Group with Hsiao Chin, Ho Kan, Hsia Yan and others, actively promoting modern art in Taiwan. Since the 1950s, Chen has been focusing on graffiti sketch art, a genre that allows artists to express their feeling as in stream of consciousness. In other words, the purpose of drawing itself is not to reproduce the reality but to help release the artists' personal emotional states.

From the 1960s onwards, Chen started to experiment with mixed media. By doing so, he attempted to recapture a common post-war feeling of desolation. In his works, all graphic symbols were eliminated, leaving only such basic elements as point, line and surface. As for the media, Chen mixed oil pigments and general copper oil. The rapid qualitative changes after their mixture could then create rich texture on the surface. Chen's paintings at this stage usually tone gray-brown. However, when bright light shines on them, fine folds and the diverse mottles on the picture surface can refract glamorous and brilliant flashes. Before the 1970s, Chen had been very active in Taiwan and his works had been very inspiring. Almost at the same time, Hsiao Chin, who has then settled in Europe, invited artists from Ton Fon Art Group to exhibit in Spain, Italy, the United States and other countries. Also, Chen was awarded by Ministry of Education and had opportunities to take part in São Paulo Bienal in Brazil, International Paris Youth Biennial, Hong Kong Asian International Art Expo, etc., in which he has won great glory and reward.

In the 1990s, Chen came back to the art field after decades of withdrawal from it. His works during this period showed a significant change in style. Instead of heavy dense oil paint he had been accustomed to apply, he now used acrylic, watercolor and other water-based pigment to create sense of fluency. He also intentionally left large blank space on the picture to allow viewers to freely browse and savor the timing of space. On one hand, such changes echoed with the artist's retrospection on his mind state when learning Chinese paintings as a kid and mimicking their artistic conception. On the other hand, they also echoed with the artist's nostalgia to Loess Plateau, the open wide nature where he had been raised.

1933 Born in Jinan, Shandong

1951 Came to Taiwan with his family and studied at Taipei Normal School (today's National Taipei University of Education)

1955 Was one of the founders of Ton Fon Art Group

1956 Chen participated in the Annual National Exhibition of Calligraphy and Painting while some works in the exhibition were purchased by the Ministry of Education and sent to Thailand as gifts for its Constitution Day. These works later became collections of Thailand National Art Museum

1957 Ton Fon Art Group held its first exhibition at Taiwan Shin Sheng Daily News Building on November 25

 Had a joint exhibition both in Galleria Jardin, Barcelona, Spain and in Taipei, Taiwan

1958	Exhibited at Krone Gallery, Spain in January
	Exhibited at Sevilla Gallery, Spain In February
	Ton Fon Art Group had a joint exhibition in Taipei along with Spanish and Ecuadorian artists in November
	Exhibited at Verena Gallery, Spain in November
1959	Awarded the first by Ministry of Education and therefore five works were selected to exhibit in São Paulo Bienal in Brazil;
	Attended in International Paris Youth Biennial and was regarded one of the most promising painters by art critics in Paris
	Exhibited at Shonchiguan Anna Artist Society, Spain in January
	Exhibited at Numeno Gallery, Florence, Italy in May
	Exhibited at Lu Gallery, Milan, Italy in June
	Exhibited again at Numeno Gallery, Florence, Italy in November Exhibited at Marsellata Gallery, Italy in November
	Ton Fon Art Group had an exhibition at Museum of Contemporary Art, Taipei, Taiwan
1960	Exhibited in Midan Gallery, NYC, USA in January
	Exhibited at Legadunogullataci Gallery, Italy in February
	Exhibited at Stevano Gallery, Venice, Italy in August
	Exhibited at Stughostosanadol Gallery, Italy in September
	Exhibited at Buchanla Gallery, Turin, Italy in October
	Won the silver medal at Asian International Art Exhibition held in Hong Kong
1961	Ton Fon Art Group had its exhibition in Taipei in November
1962	Exhibited at Valasse Gallery, Italy
1965	Works were again selected by Ministry of Education to exhibit in São Paulo Bienal in Brazil
1980	Had a joint exhibition with Yang Shing Sheng at Rovo Gallery, Taipei, Taiwan
1981	Ton Fon Art Group and the Fifth Month Art Group collaboratively curated a joint exhibition to celebrate their 25th anniversary at National Museum of History, Taipei, Taiwan
1996	Chen's work Children and Horses became a collection of Taipei Fine Arts Museum
1997	Ton Fon Art Group and the Fifth Month Art Group organized a joint exhibition to celebrate their 40th anniversary at National Taiwan Museum of Fine Arts, Taichung, Taiwan
2012	"Exploring the Wasteland – The Eight Highwaymen of the East", Da Xiang Art Space, Taichung, Taiwan

吳 昊

1932	出生於南京市
1948	就讀蘇州省立工專預備科。到上海乘新康輪來台
1950	隨李仲生習畫
1952	與歐陽文苑、夏陽進駐防空洞作畫
1956	與七為位畫家成立東方畫會
1957	台北東方畫展同時，蕭勤在西班牙策劃海外東方畫展
1966	正式開始版畫創作，加入「現代版畫會」
1971	第十五屆「東方畫會」展，同時解散
1987	擔任中華民國版畫學會董事長
	「李仲生現代繪畫文教基金會」成立並任董事長
1991	舉辦首屆「李仲生現代繪畫文教基金會現代繪畫獎」
1993	國家文藝獎評審委員
1994	國家文藝獎評審委員
1995	舉辦第三屆「李仲生現代繪畫文教基金會現代繪畫獎」

個展

1971	「吳昊現代版畫展」於台北聚寶盆畫廊，台北，台灣
1973	於德國石峽市舉辦版畫及素描個展，德國
1974	油畫版畫個展，鴻霖畫廊，台北，台灣
	油畫版畫展，聚寶盆畫廊，台北，台灣
1975	應邀版畫個展，香港中文大學，香港，中國
1976	版畫個展，集一畫廊，香港，中國
1977	版畫個展，藝術家俱樂部，台北，台灣
1978	版畫個展，版畫家畫廊，台北，台灣
1979	首次油畫個展，版畫家畫廊，台北，台灣
1980	個展，龍門畫廊，台北，台灣
1983	個展，龍門畫廊，台北，台灣
1986	個展，名門畫廊，台中，台灣
1991	台中當代畫廊、台北龍門畫廊個展，台灣
1992	個展，龍門畫廊，台北，台灣

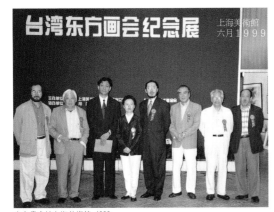

東方畫會於上海美術館, 1999
A group photo of Ton Fon Art Group at Shanghai Art Museum in 1999

1994	邀請舉辦「吳昊四十年創作展」，台北市立美術館，台北，台灣
1997	「吳昊的繪畫歷程展」，台灣省立美術館，台中，台灣
	「吳昊個展」，龍門畫廊，台北，台灣
1999	個展，帝門藝術中心，台北台中，台灣
2001	「人間花影」個展，龍門畫廊，台北，台灣
	「吳昊個展」於國立中央大學藝文中心，桃園，台灣
2002	「陌上花開蝴蝶飛－－吳昊油畫展」個展，形而上畫廊，台北，台灣
2006	「花開了」吳昊油畫展，形而上畫廊，台北，台灣
2007	「陌上花兒開－吳昊個展」，月臨畫廊，台中，台灣
2009	個展，月臨畫廊，台中，台灣

聯展（部份）

1956	中華民國45年全國美展
	「第一屆東方畫展」在台北衡陽街新聞大樓
1957/1958/1961/1962/1963/1964	
	「東方畫展」於西班牙、巴西、巴黎、義大利、紐約展出
1958-1971	第二至第十五屆「東方畫展」於台北，台灣
1983	台北市立美術館開館展．台北，台灣
1994	高雄市立美術館開館邀請展，高雄，台灣
	「史詩大展」，皇冠藝術中心，台北，台灣
1996	「東方、五月畫會四十週年聯展」，高雄積禪五十，高雄，台灣
1999	「李仲生師生聯展」，台灣省立美術館，台中，台灣
2003	「東方式的浪漫」，形而上畫廊，台北，台灣
2005	「動靜之間」，形而上畫廊，台北，台灣
2012	「藝拓荒原→東方八大響馬」，大象藝術空間館，台中，台灣

得獎

1972	榮獲中華民國畫學會「金爵獎」
1979	參加第六屆英國國際雙年版畫展獲「爵生獎」
1980	榮獲版畫協會「金璽獎」

Wu Hao

1932	Born in Nanking, China.
1948	Attends preparatory courses at Suzhou Provincial Vocational High School
	From Shanghai to Taiwan by ship"New Health"
1950	Begins studies with Li Chuhshan
1952	Begins painting at bomb shelter along with Oyan Wenyuan and Hsia Yan
1957	Concurrent with Taipei Ton Fon Group Exhibition, Hsiao Chin organizes Ton Fon exhibition in Spain
1966	Begins concentration on printmaking, participates in Modern Print Society
1967	Participates in contemporary artist exhibition in United States
	Department of National Defense Medal of Exemplary Conduct
1971	1971 International Contemporary Graphic Exhibition, Rome and Milan,Italy
	15th and final Ton Fon Group Exhibition
1972	Mostra International De Xilografia Milano, Italy
1973	Chinese Artists Exhibition, Washington, D.C
1987	Chairman of Chinese Modern Graphic Society
	Li Chuhshan Modern Painting Education Foundation founded, acts as chairman
1991	Presenter, Li Chuhshan Modern Painting Education Foundation Award
2004	Created "The Joyous Scene in Spring" 330x130cm Oil Painting

Solo Exhibitions

1971	Wu Hao's 1971 Solo print exhibition at the Cornucopia Gallery, Taipei, Taiwan
1973	Print and sketch show, Germany.
1974	Morrison Art Gallery, Taipei, Taiwan
	Print show, exhibition at the Cornucopia Gallery, Taipei, Taiwan
1975	Print show, Chinese University, Hong Kong.
1976	Che Art Gallery, Hong Kong.
1977	Print show, Artists' Club, Taipei, Taiwan
1978	Print and sculpture show, Artists' Club, Taipei, Taiwan
1979	Oil painting show, Print Maker's Gallery, Taipei, Taiwan
1980	Oil painting exhibition, Lung Men Art Gallery, Taipei, Taiwan

1983	Oil painting exhibition, Lung Men Art Gallery, Taipei, Taiwan
1983	Oil painting exhibition, Lung Men Art Gallery, Taipei, Taiwan
1986	Ming Men Art Gallery, Taichung, Taiwan
1991	Contemporary Art Gallery, Taichung, Taiwan
1992	Lung Men Art Gallery, Taipei, Taiwan
1994	"Wu Hao-Works in 40 years" Taipei Fine Arts Museum, Taipei, Taiwan
1997	"Wu Hao's Journey"Exhibition at the Taiwan Museum of Art, Taichung, Taiwan
1999	Oil painting exhibition, De Men Art Gallery, Taipei, Taiwan
2001	Oil painting exhibition, Lung Men Art Gallery, Taipei, Taiwan
	National Central University Art Center, Taoyuan, Taiwan
2002	"Dancing Butterflies Blooming the Paths" One-man oil painting exhibition, Metaphysical Art Gallery, Taipei, Taiwan
2006	"Blooming Season" Wuo Hao oil painting exhibition, Metaphysical Art Gallery, Taipei, Taiwan

Group Exhibitions (Partial lists)

1956	First Ton Fon Art Group Exhibition at the Taipei News Building, Taipei, Taiwan
1958~1965	Second to Ninth Ton Fon Art Group Exhibition, Taipei, Taiwan
1967~1970	Tenth to Fourteenth Ton Fon Art Group Exhibition, Taipei, Taiwan
	Fifteenth and final Ton Fon Art Group Exhibition, Taipei, Taiwan
1983	Grand Opening Group Exhibition, Taipei Fine Arts Museum, Taipei, Taiwan
1992	Group exhibition, Caves Art Gallery, Taichung, Taiwan
1993	Three-man exhibition Crown Art Center, Taipei, Taiwan
1994	Grand Opening Group Exhibition, Kaohsiung Museum of Fine Arts., Kaohsiung, Taiwan
1999	"Li Chuhshan with students", Modern Art Centre, Taichung, Taiwan
2002	"Happy New Year - Horse" special exhibition, Metaphysical Art Gallery, Taipei, Taiwan
2003	"The Eastern Romantic" Metaphysical Art gallery, Taipei, Taiwan
2005	"Between Moving and Still" Metaphysical Art gallery, Taipei, Taiwan
2012	"Exploring the Wasteland – The Eight Highwaymen of the East", Da Xiang Art Space, Taichung, Taiwan

Awards

1972	Golden Cup Award, Art Society of China Institute, Taipei, Taiwan
1979	Golden Cup Award, Art Society of China Institute, Taipei, Taiwan
1980	Golden Seal Prize, conferred upon by Painting Art Society, Taipei, Taiwan

霍　剛

1932　本名霍學剛，七月二十三日（農曆六月二十日）出生於南京。父親霍道成，母親桑玉華

1937　小時為了怕在牆上塗鴉會挨揍，又缺乏紙張，便將家中桌子的所有抽屜翻轉過來當畫紙畫畫

1938　抗日戰爭時舉家移居重慶。搬回南京與祖父同住

1942　任職軍政部中校的父親過世。搬回南京與祖父同住

　　　祖父霍鋭號退盫居士，為江南知名書法家，在藝術上受其薰陶與啟發

1949　隻身與國民革命軍遺族學校來台灣

1950　遺族學校初中畢業，入台北師範學校藝術科（今國立台北師範學院美術教育系）就讀。進師範學校前寄讀師大附中，結識上海美專李文漢先生，開始接觸有關西洋藝術理論，
　　　對素描早有概念。經歐陽文苑介紹赴二女中，拜訪李仲生先生

1951　入台北市安東街李仲生畫室，研習現代繪畫，展開其現代藝術的繪畫歷程

1953　師範學校畢業後，分發至景美國小任教。促成全省第一個國民學校美術教室，指導兒童發展自由畫，同時自己也開始畫創作性的素描和油畫
　　　喜用藍、綠、灰等冷色，在形式上有新古典主義及超現實主義的傾向

1954　加入台灣省教育廳教師研習會。由於歐陽文苑之弟歐陽仁為景美國校同事，且蕭勤於本年分發至景美國小任教，安東街畫室畫友乃選在景美國小，每月第一個星期日定期聚
　　　會一次，共組繪畫觀摩會

1955　研究超現實主義，並通過立體主義的構成原理，作潛意識的探討。此時常以粉臘筆作畫，色彩冷靜而明柔。受達利、米羅及莫弟良尼等之影響，同時也畫了許多類似的素描
　　　李仲生關閉安東街畫室，遷居員林

1956　此時創作以素描與油畫為主，色彩漸趨明朗。與吳昊、李元佳、陳道明、夏陽、歐陽文苑、蕭勤、蕭明賢等籌組創辦中國第一個現代繪畫團體－「東方畫會」，號稱「八大響
　　　馬」。「東方」之名由霍剛所提議，經表決通過。該會主要尋求以現代藝術的形式來表現東方的觀念與內涵

1957　擔任全省國民教育巡迴輔導團美術輔導員至一九五八年。此期間曾選寄不少兒童畫給蕭勤，於西班牙舉辦「中國兒童畫展」為國內兒童藝術引介到海外展覽之肇始。「第一
　　　屆東方畫展」十一月假台北衡陽街新生報新聞大樓舉行，賣出第一幅油畫。之後每年舉行一次畫展，霍剛參展至一九六五年

霍剛與李仲生_1956
Ho Kan and Li Chuhshan in 1956

1958	嘗試以自動性技法作畫，並加強作品的抽象性
1959	從原始洞窟壁畫，與中國書法碑帖中吸收滋養，創作許多水墨素描。作品多半寄往國外或送人
1963	創作仍以水墨素描為主，畫幅變大，在表現上也較自由、豪放，同時摻用藍、紅色。出國前和夏陽於西門町閒逛，被街頭算命師建議改名為「柔存」，但即將遠赴異鄉，非但不能學柔還需要更獨立堅強，便改為單名-「剛」字，而「柔存」則僅配合名之
1964	搭法國油輪「越南號」前往歐洲。經法國與住巴黎的夏陽和蕭明賢會面，後轉往義大利定居米蘭至今
1965	出國後的一大轉變，就是逐漸將不必要的形象刪除，減輕筆觸與線條，色彩亦較以往明朗。獲義大利古比奧市國際藝術發展獎
1966	獲義大利古比奧市國際藝術發展獎 獲義大利諾瓦拉市國際繪畫金牌獎
1967	獲義大利孟扎市國家繪畫首獎
1969	獲義大利萊科市久賽彼・莫利首獎
1981	「東方」與「五月」兩畫會在台灣省立博物館舉行成立二十五週年聯展
1990	個展於台北誠品畫廊舉行，畫作開始由該畫廊代理至一九九五年
1994	台灣省立美術館舉行個展，台中，台灣
1997	台北帝門藝術中心「東方現代備忘錄-穿越彩色防空洞」聯展，台北，台灣 獲第五屆「李仲生基金會現代繪畫獎成就獎」
1999	返台參加省立美術館舉辦之「李仲生師生展」，與帝門藝術中心舉辦之「霍剛的歷程」個展，台北，台灣
2001	「東方的結構主義」台北帝門藝術中心個展，台北，台灣
2010	台中大象藝術空間館個展，台中，台灣
2011	藝載乾坤— 霍剛校園巡迴展於清華大學藝術中心、靜宜大學藝術中心、成功大學藝術中心
2012	「藝拓荒原→東方八大響馬」，台中大象藝術空間館，台中，台灣

Ho Kan

1932 Named Ho Hsueh Kan, born in Nanching, July 23th. Father, Ho Tao-chen; Mother, Sang Yu-hua

1937 As a child, Ho Kan was afraid of being punished for scribbling on walls and also lacking paper, he turned all the drawers upside down and drew on the bottom side of them.

1938 During the Sino-Japanese War, he moved to Chungching. He always received the highest markds in art and craft courses while he was in elementary school

1942 He moved back to live with her grandfather when his father passed away

Grandfather Ho Rei also called Tueisachushi, was a well known as a great Chinese calligrapher who enlightened Ho Kan on his artistic development

1949 Came to Taiwan alone with the revolut ionary military dependent's school

1950 Accepted by Taipei Normal School Art Department after graduating from high school. In the preparatory courses, he met Li Wen-han. Ho Kan started reading books about art introduction and art theories, and obtained basic skills and concepts of sketch. Introduced by Oyan Wenyuan, Ho Kan met Li Chuhshan

1951 Ho Kan attended Li Chuhshan's studio on An-tong street and studied Western paintings. This was the beginning of his dedication and devotion to modern arts

1953 Kan taught in Chingmei Elementary School right after graduation from Normal School and help establishing the first art studio for youngsters in Taiwan and encouraged students to draw with feelings. Meanwhile, he started creative sketches and oil painting scenery and still life. He painted with blue, green or gray, and was influenced by neoclassicism and surrealism

1954 Joined the Teacher Association

Hsiao Chin was also accepted into Chingmei Elementary School to teach art class. Several friends from Li Chuhshan studio started their salon and held meeting every first Sunday of the month in Chingmei Elementary School campus

1955 Ho Kan studied surrealism and researched subconsciously through the theory of cubism. At the same time, he pastel painted with calm and soft color and his sketches were similar in style to the work Dali, Miro, and Modigliani. Li Chuhshan closed his studio on An-tong Street and moved to Yuanlin

1956 Sketches and oil paintings were the major works he was creating. The colors he used were getting brighter. He was on of the co-founders of the first modern art association in China with Wu Hao, Li Yuanchia, Chen Taoming, Hsia Yan, Oyan Wenyuan, Hsiao Chin and Hsiao Minghsien, who were called as "Eight Highwaymen". Ho Kan suggested to name this group "Ton Fon" (Eastern) as the meaning of exploring Eastern ideas and concepts and expression in the form of modern art

1957 He was an instructor of the art education touring council until 1958. During this period, Ho Kan mailed Hsiao Chin great pieces of children's paintings and held " Art Exhibition of Chinese Children's" in Spain. That was the beginning of the overseas exhibition on Children's art in Taiwan. The first exhibition of "Ton Fon" was held in the Shin-Shung News Building on Hung-Yang street, Taipei, where Ho Kan sold his first piece of oil painting. "Ton Fon" has put on an exhibition every year since. Ho Kan attended the exhibitions till 1965

1958 Tried to paint with Automatism skill and to strengthen abstract concept

1959 Learned the ideas from cave painting and Chinese calligraphy, Ho Kan created ink and wash sketches. He delivered most of these work abroad or sent to friends as gifts.

1963 Sketched mainly in ink and wash. The size of his work became larger. He expressed his work more freely and vigorously. Meanwhile he started using the color blue and red

 Wondered around Shimenting with Hsia Yan before going abroad. A fortuneteller on the street suggested Ho Kan to change his name to Ro-Cuen. (which means tender)

 However, shortly before going abroad, he could no be tender, on the contrary should be tough and independent. He turned out to change his name as Kan. (which means solid)

 Ro-Cuen became his other name

1964 Took French oceanliner named "Vietnam" to Europe. Stopped by Paris and met Hsia Yan and Hsiao Minghsien, he left for Italy and has lived in Milan-Shian.

1965 Tremendous change happened after Ho Kan went to Italy. He gradually left out unnecessary forms and lightened his tones and lines. The color he used was brighter. Winner of

 International Art Development Price, Bubbio, Italy

1966 Winner of International Art Development Price, Bubbio, Italy

 Winner of International Paint Golden Price, Novara, Italy

1967 Winner of National Paint Golden Price, Monza, Italy

1969 Winner of Giuseppe Mori Golden Price, Lecco, Italy

1981 25th anniversary joint exhibitions of "Ton Fon" and "Fifth Moon" group in Taipei, Taiwan

1990 Solo exhibition in Cheng Pin Gallery in Taipei, which was the agent for Ho Kan's work till 1995

1994 Solo exhibition in Taiwan Museum of Art, Taichung, Taiwan

1997 Joint exhibition "The Memo of Ton-Fan" Dimensions Art Center, Taipei. Winner of Modern Art Achievement Price, Li Chuhshan Foundation

1999 Joint exhibition "Li Chuhshan and his Pupils exhibition" Dimensions Art Center, Taipei, Taiwan

2001 Solo exhibition in Dimensions Art Center, Taipei, Taiwan

2010 Solo exhibition in Da Xiang Art Space, Taichung, Taiwan

2011 University Etemity - Ho Kan Solo exhibition in National Tsing Hua University Arts Center, Providence University Arts Center, Cheng Kung University Arts Center, Taiwan

2012 "Exploring the Wasteland – The Eight Highwaymen of the East", Da Xiang Art Space, Taichung, Taiwan

夏　陽

1932	生於湖南湘鄉，本名夏祖湘
1948	畢業於南京市立師範簡師
1949	隨軍抵台，服務軍旅
1951	隨李仲生習畫
1956	與畫友蕭勤、蕭明賢、吳昊、李元佳、霍剛、歐陽文苑、陳道明等人創立「東方畫會」
1957	和畫友八人聯合創立東方畫會於台北，首次展出東方畫展。
1963	初訪歐洲，後定居巴黎5年
1965	進巴黎高等美術學校修業兩年
1968	移居美國紐約
1973	入紐約O.K.哈里斯畫廊成為其專屬畫家
1992	返回台北定居
2000	財團法人國家文化藝術基金會 第四屆文藝獎美術類得獎者
2002	移居上海迄今

個展

1961	米舟畫廊，紐約，美國
1965	杜－峨巴未畫廊，巴黎，法國
1967	杜－峨巴未畫廊，巴黎，法國
1971	O.K.哈里斯畫廊，紐約，美國
1977	O.K.哈里斯畫廊，紐約，美國
1980	版畫家畫廊，台北，台灣
1982	O.K.哈里斯畫廊，紐約，美國
1984	O.K.哈里斯畫廊，紐約，美國
1987	O.K.哈里斯畫廊，紐約，美國
1989	誠品畫廊，台北，台灣
1991	誠品畫廊，台北，台灣
1992	新展望畫廊，台中，台灣
1993	誠品畫廊，台北，台灣
1994	台北市立美術館「夏陽創作40年回顧展」，台北，台灣
1996	誠品畫廊，台北，台灣
1998	省立美術館「夏陽回顧展」，台中，台灣
1999	帝門藝術中心，台北，台灣
2000	誠品畫廊，台北，台灣
2003	誠品畫廊，台北，台灣
2005	視平線畫廊「歸來的星光-夏陽的個展」，上海，中國
2006	視平線畫廊，上海，中國
	上海美術館，上海，中國
	誠品畫廊，台北，台灣

聯展

1956	中華民國四十五年全國書畫展
1957	歷屆及歐美各地之東方畫展
1959	巴西聖保羅雙年展
1959	巴黎青年畫家展
1962-1963	中國青年畫家展（義大利米蘭等地）
1964	中國畫家聯展，巴黎，法國

蕭明賢、夏陽、霍剛於巴黎
Hsiao Minghsien, Hsia Yan, and Ho Kan in Paris

1965	中國現代畫家展，羅馬，義大利
1974	具象之傾向，克利夫蘭美術館，俄亥俄州，美國
1975	視象之改變，阿爾代里期現代美術館，康內得肯州，美國
1976	今日美國的繪畫和雕刻，波里美術館，印第安那州，美國
1977	新舊收藏展，南德克薩斯州美術館
1977-78	照像寫實主義，聖派德斯堡美術館
1978	舊傳承和新方向，阿爾特爾那提大國際藝術中心，紐約，美國
1979	托勒多現代收藏展，托勒多美術館
1980	美國五〇~八〇具象畫展，克利斯勒美術館
1981	紐約影像展，大都會美術館，東京，日本
1982	海外華裔名家繪畫展，香港美術館，香港
1983	紐約的繪畫，紐約市立美術館，紐約，美國
1984	台灣畫家六人展，北京美術館，北京，中國
1985	國際彩墨畫展，台北市立美術館，台北，台灣
	美國寫實主義，伊勢丹美術館，東京，日本
	七〇~八〇年代之藝術，阿爾代里斯現代美術館，康內得肯州，美國
1986	紐約畫家十一人展，廣東，中國
1987	上海－台灣畫家展，上海，中國
1990	當代畫家素描展，誠品畫廊，台北，台灣
1991	台北－紐約畫家聯展，台北市立美術館，台北，台灣
	東方-五月畫家35週年展，時代畫廊，台北，台灣
1993	當代畫家早期作品展，欣賞家畫廊，台北，台灣
	台灣90's新觀念族群，漢雅軒，台北，台灣
1994	台北現代畫展，曼谷國家美術館，泰國
1995	門神新年代－藝術家聯展，皇冠藝文中心，台北，台灣
	牽手紀念日－夫妻聯展，皇冠藝文中心，台北，台灣
1996	伊通聯展，伊通公園，台北，台灣
	台灣的傳承與展望－漢雅軒精選，漢雅軒，台北，台灣
	夏陽-廖修平聯展，新台北藝術聯誼會，台北，台灣
	「五月、東方，現代情」兩畫會四十週年展，積禪藝術中心，高雄，台灣
	圖象後現代，日升月鴻藝術畫廊，台北，台灣
1997	東方-五月40週年紀念展，高雄、台中、台北、金門，台灣
	台北現代畫展，上海美術館，上海，中國
1998	台北現代畫展，新町美術館，信州，日本
	東方現代備忘錄－穿越彩色防空洞，帝門藝術中心，台北，台灣
	悍圖錄，皇冠藝文中心，台北，台灣
	典藏常設展－萌芽. 生發. 激撞，台北市立美術館，台北，台灣
1999	亞太三年展，昆士蘭美術館，澳洲
2003	美術節特展－國家文藝獎得主作品展，福華沙龍，台北，台灣
	藝象－國家文藝獎五大名家聯展，國立台南藝術學院藝文中心，台南，台灣
	觀念與表現-藝術家聯展，視平線畫廊，上海，中國
2005	「夏陽 VS. 袁旃」，誠品畫廊，台北，台灣
2006	「意象武夷」，上海美術館，上海，中國
2010	「陳夏雨、熊秉明、夏陽雕塑展」，誠品畫廊，台北，台灣
	「上海2010雙年展」，上海美術館，上海，中國
2012	「藝拓荒原→東方八大響馬」，大象藝術空間館，台中，台灣

Hsia Yan

1932	Born in Human, China
1948	Graduated from the Normal College
1949	Arrived in Kaohsiung, Taiwan with the army
1951	Studied with painter, Li Chuhshan
1955	Found the group "Ton Fon" in Taipei
1965	Traveled to Paris
1968	Resided in New York
1973	O.K. Harris accepted him as their agent artist
2000	National Culture and Arts Foundation 4th Literary and Arts Award
2002	Traveled to Shanghai, China

Solo Exhibitions

1961	Mi-Chou Gallery, New York, USA
1965	Galerie du Haut Pave, Paris, France
1967	Galerie du Haut Pave, Paris, France
1974	O.K. Harris Works of Art, New York, USA
1977	O.K. Harris Works of Art, New York, USA
1980	Graphic Gallery, Taipei, Taiwan
1982	O.K. Harris Works of Art, New York, USA
1984	O.K. Harris Works of Art, New York, USA
1987	O.K. Harris Works of Art, New York, USA
1989	Eslite Gallery, Taipei, Taiwan
1991	Eslite Gallery, Taipei, Taiwan
1992	New Trends Gallery, Taichung, Taiwan
1993	Eslite Gallery, Taipei, Taiwan
1994	"Forty Years of Hsia Yan", Taipei Fine Arts Museum, Taiwan
1996	Eslite Gallery, Taipei, Taiwan
1998	"Retrospective exhibition of Hsia Yan", National Taiwan Museum of Fine Arts, Taichung, Taiwan
1999	Dimensions Art Center, Taipei, Taiwan
2000	Eslite Gallery, Taipei, Taiwan
2003	Eslite Gallery, Taipei, Taiwan
2005	"Return of Starlight", Eye Level Gallery, Shanghai, China
2006	Eye Level Gallery, Shanghai, China
	Shanghai Art Museum, Shanghai, China
	Eslite Gallery, Taipei, Taiwan

Group Exhibitions

1956	Participated in the 1956 National of Paintings and Calligraphies, R.O.C.
1959	Bienalle of Sao Paulo, Brazil
	Bienalle of Young Artists,Paris, France
1962-1963	Young Chinese Artists, Savona, Milan, Italy
1964	Chinese Artists Group Exhibitions, Paris, France
1965	Modern Art of the Republic of China, Gallery of the Palace of Exhibitions, Rome, Italy
1974	Aspects of the Figure, Cleveland Museum of Art, Cleveland, OH., USA
	New Realism, Skidmore College, Sarasota Spring, NY., USA
1975	A Change of View, Aldrich Museum of Contemporary Art, Ridgefield, CT., USA
1976	Urban Aesthetics Queens Museum, Flushing, NY. , USA
	The Presence and Absence in Realism, State College at Potsdam, NY., USA
	Painting and Sculpture Today '76, Indianapolis Museum of Art, Indianapolis, IN., USA
1980	American Figure Painting 50-80, the Chrysler Museum, Norfolk, VA., USA
	Photo Realism, Museum of Fine Arts, St. Petersburg, FL., USA
1981	Tokyo Metropolitan Art Museum, Tokyo, .Japan (An Exhibition Organized by
	the Whitney Museum of American Art, New York and Tokyo Metropolitan Art Museum)
1982	Paintings by Leading Overseas Chinese Artists, Hong Kong Museum of Art, Hong Kong, China
1983	Paintings in New York, Museum of The New York City, USA
1984	Six Artists from Taiwan, Beijing Museum of Art, China
1985	American Realism: The Precise Image, Isetan Museum of Art, Tokyo, Japan
1986	Eleven New York Artists Works Exhibition, Guangdong Academy, China
1987	Artists of Taiwan and Shanghai, Shanghai, China
1990	Contemporary Artists Drawing Exhibition, Eslite Gallery, Taipei, Taiwan
1991	The Exhibition: Taipei—New York, Taipei Fine Arts Museum, Taipei, Taiwan
1996	A Contemporary View of Taiwanese Arts-Hanart's Choice, Hanart Ga1lery, Taipei, Taiwan
	G. Zen 50 Art Gallery, Kaohsiung, Taiwan
	Ever Harvest Art Gallery, Taipei, Taiwan
1997	An Exhibition of Ton Fon/May Groups for 40th Anniversary, Kaohsiung, Taichung/ Taipei/ Kinmen, Taiwan
1998	Taipei Modern Painting Show, Japan
	Ton Fan's Modem Memorandum—through a colorful bomb shelter, Dimensions Art Center, Taipei, Taiwan
1999	Asia-Pacific Triennial of Contemporary Art, Queensland Art Gallery, Australia
2003	Achievement Award, Howard Salon, Taipei, Taiwan
	Art Center TNCA, Art Center Tainan National College of the Arts, Tainan, Taiwan
2005	HSIA YAN vs. YUAN JAI, Eslite Gallery, Taiepi, Taiwan
	Special Show of Fine Arts Festival—The Winners' Works of National Literature and Art
2006	IMAGERY of MT. WUYI, Shanghai Art Museum, Shanghai, China
2012	"Exploring the Wasteland – The Eight Highwaymen of the East", Da Xiang Art Space, Taichung, Taiwan

蕭 勤

1935	生於上海。父親蕭有梅於1927年在上海創立上海音樂學院，為中國近現代音樂的啟蒙者
1949	隨姑丈王雪艇赴臺，入臺中二中後轉臺北成功中學
1951	蕭勤就讀於台北師範學校藝術科（今國立台北教育大學）
1952	蕭勤入李仲生畫室習藝，為研究現代藝術之開始
1954	台北師範學校畢業，入景美國小服務
1956	在台北與夏陽、吳昊、李元佳、陳道明、蕭明賢、歐陽文苑、霍（學）剛創辦全中文地區地一抽象繪畫的團體「東方畫會」。七月獲西班牙政府獎學金，赴馬德里研習
1957	第一屆東方畫展亦於年底在臺北及巴塞隆納花園畫廊同時展出
1959	蕭勤在義大利翡冷翠數字畫廊（Galleria Numero）舉辦首次個展，之後於遷居義大利米蘭
1961	與義大利畫家卡爾代拉及日本雕塑家吾妻兼治郎發起國際「點」藝術運動，曾在義大利、西班牙、荷蘭、台北等地展出。在米蘭阿農查德沙龍畫廊舉行第一次個展，結識馬爾柯尼畫廊人，開始與之訂立多年合約
1962	與義大利女畫家畢卓結婚
1963	透過馬爾各尼與達爾疆（M.D'Arguian）所主持之巴黎當代藝術畫廊締約
1964	赴巴黎工作，並於當代藝術畫廊舉行個展，為期三個月
1966	赴倫敦工作半年，並在信息畫廊展出
1967	首次赴紐約居住
1969	在紐約長島大學之南漢普頓學院教授繪畫及素描，結識德庫寧（W. De Kooning）。與畢卓分居
1971~1972	於米蘭歐洲設計藝術學院任教視覺原理
1972	於美國路易西安那州立大學教授繪畫及素描。年底赴墨西哥參觀阿茲特克及馬雅建築
1978	在米蘭與提爾遜（J. Tilson），洛布司提（G. Robusti），吾妻兼治郎發起創辦國際SURYA（太陽）藝術運動。應邀返臺參加文建會，是第一位與會的藝術家，提出建立美術館及舉辦中外藝術交流多項倡議。並在省立歷史博物館舉行個展
1980	北京與上海舉行其父蕭友梅逝世四十周年紀念活動，應邀前往參加；並在北京文化部紅旗禮堂講介西方二十世紀藝術，還是蕭勤三十一年來第一次重返大陸
1981	東方與五月畫會在臺北舉行成立二十五周年展出
1983~1984	在義大利烏爾皮諾國立藝術學院教授藝術解剖及畫面分析
1984~1985	在義大利都林國立藝術學院教授裝飾藝術
1985	始以米蘭國立藝術學院教授版畫藝術至1997年，現已為永久聘任
1988	赴蘇聯，參加義大利當代藝術在莫斯科展出，並走訪列寧格勒。在米蘭馬爾各尼畫廊舉行大型三十周年回顧展
1990	在米蘭馬爾各尼畫廊舉行大型三十周年回顧展
1991	東方及五月畫會在台北舉行成立三十五週年展出
1992	「蕭勤舉行回顧展」 臺灣省立美術館，台中，台灣

歡送蕭勤將赴西班牙，於景美國校，1956 前排左起：劉芙美 陳道明 李元佳 夏陽　後排左起:朱為白 金藩 歐陽文苑 霍剛 蕭勤 吳昊 蕭明賢
A farewell party for Hsiao Chin going Spain at Jingmei National Primary School in 1956　Front row, from left, Liu Fumei, Chen Taoming, Li Yuanchia, Hsia Yan. Back row, from left, Chu Weibor, Jin Fan, Oyan Wenyung, Ho Kan, Hsiao Chin, Wu Hao, Hsiao Minghsien

1994 北京中央美術學院及杭州中國美術學院為蕭勤舉行回顧展，此為蕭勤首次在中國展出

1995 「蕭勤的歷程：1953-1994」展，臺北市立美術館，台北，台灣

1996 帝門藝術教育基金會為蕭勤舉行回顧展。五月與抒情女高音莫尼卡（Monika Unterbenger）在奧地利結婚。十月起應聘於臺南藝術大學造型藝術研究所擔任繪畫專任教授

1997 於帝門藝術中心舉行「聚合能量─度大限到新世界系列」1990-1997年近作發表。並在臺北、佛羅倫斯展出

1998 在巴黎巡迴展出。並於德國達姆斯特達（Darmstadt）的瑪蒂登荷亥市立美術館（Institut Mathildenhohe）舉行「蕭勤1958-1998 歷程創作展」。應「98年上海雙年展」之邀
參與展出

2000 第七屆威尼斯國際建築雙年展（臺灣館），威尼斯，義大利

「蕭勤的海外遺珍」展，台北帝門藝術中心，台北，台灣

2002 於米蘭舉行四個大型回顧展：馬爾各尼畫廊（1958-2001繪畫作品），米蘭，義大利

於米蘭慕狄瑪藝術基金會Fondazione Mudima（2001 大幅新作），米蘭，義大利

拉都阿達畫廊Studio Lattuada（歷年的紙上作品）

米蘭省政府奧拜堂空間Spezio Oberdan（歷年的陶作），米蘭，義大利

榮獲第六屆臺灣國立文藝獎（美術獎）

2003 「走向新世界─2003蕭勤巡迴展」，國立文藝基金會

2月份新竹交通大學藝文中心。4月份基隆海洋大學藝文中心。5月份臺南成功大學藝文中心。9月份中壢中央大學藝文中心。10月份高雄中山大學蔣公行館

12月份帝門藝術中心舉行「華人現代藝術先行者─蕭勤2003個展」。12月份至2004年2月國立臺南藝術大學之臺南藝象藝文中心展出

2004 「蕭勤繪畫歷程展1958-2004」，上海美術館，上海，中國

2005 榮獲義大利總統頒『團結之心』騎士勳章

從國立臺南藝術大學退休，獲聘『榮譽教授』

廣州廣東美術館1954-2004歷程展

廣東中山美術館1954-2004歸源之旅，廣東，中國

2006 「榮源-蕭勤七十回顧展1955-2005」北京中國美術館，北京，中國

「蕭勤的心」6月臺灣臺北大未來畫廊，台北，台灣

2007 北京大未來畫廊之開幕聯展，北京，中國

「抽象中國」聯展，北京大未來畫廊，北京，中國

2008 「老幹新枝又一春－臺北B館開幕展」聯展， 臺北大未來畫廊，台北，台灣

2010 「大　之境:蕭勤75回顧展－向大師致敬系列」臺灣高雄市立美術館，高雄，台灣

2011 「蕭勤1955-2010作品展」臺北大未來林舍畫廊，台北，台灣

2012 「藝拓荒原→東方八大響馬」，大象藝術空間館，台中，台灣

Hsiao Chin

1935 Born in Shanghai; father Hsiao Yu-mei, a pioneer in contemporary Chinese music, founded China's first music school, the Shanghai Conservatory of Music, in Shanghai in 1927.

1949 Accompanies uncle Wang Hsueh-ting to Taiwan; transfers from Taichung No.2 Junior High School to Taipei's Chengkung Junior High School

1951 Enters the Art Department at Provincial Taipei Teacher's College under adviser Chou Ying; studies

1952 Joins Li Chuhshan's Antung St. studio, commencing study of modern art

1954 Graduates from Taipei Teacher's College, begins teaching at Ching Mei Elementary School

1956 Together with Hsia Yan, Wu Hao, Li Yuanchia, Chen Taoming, Hsiao Minghsien, Oyan Wenyuan, and Ho Kan, participates in the founding of the first Chinese abstract painting movement, the Ton Fon Art Group in Taipei. In July, receives a scholarship from the Spanishgovernment and heads to Madrid; upon discovering the extreme conservatism of the Academia de Bellas Artes de San Fernando, Madrid, decides not to matriculate there and in November moves to Barcelona

1957 The first Ton Fon Art Group Exhibition is held at year's end simultaneously in Taipei and Barcelona Galeria Jardin. Began to make friends with most active abstract artist of Spain at that time. He also writes avant-garde arts series articles of Western Hemisphere for United Daily News, Taipei

1959 First solo show in Italy, at Florence's Galleria Numero; moves to Milan

1961 Founded International Punto Art Movement together with Italian Painter A. Calderara and has been exhibiting in Italy, Spain, Holland and Taipei, and there were several Spanish, French and Dutch artists joining the movement. He held his first Solo Exhibition in Salone Annunciata gallery in Milano and met G. Marconi and entered contract of several years

1962 Marries Italian painter Giuseppa Pizzo

1963 Marconi and M. D'Arguian assist Hsiao Chin to enter contractual agreement with the prominent Galerie Internationale d'Art Contemporain, Paris

1964 Works in Paris for three months; hold solo exhibition at Galerie Internationale d'Art Contemporain

1966 Works in London for six months; exhibits at the Signals Gallery

1967 Visits New York for the first time, remains there through 1971; daughter Samantha is born in New York. Solo exhibition at Rose Fried Gallery, New York. Became friend of M. Rothko. Teaches painting and drawing at Long Island University's South Hampton College, N.Y.; meets William De Kooning. Separates from Giuseppa Pizzo

1971~1972 Teaches visual theory at Milan's Istituto Europeo di Design

1972 Teaches painting and drawing at State University of Louisiana, United States. Travels to Mexico to visits Aztec and Maya architecture

Founded the international SURYA movement in Milan together with J. Tilson, G. Robusti and Kengiro Azuma. Returns to Taiwan by invitation as the first artist to participate in Taiwan

1978 Reconstruction Council; proposes the construction of art museums and the sponsorship of various international arts exchange programs. Major solo exhibition at National Museum of History in Taipei

1980 Participates by invitation in events in Beijing and Shanghai commemorating the 40th anniversary of father Hsiao Yu-men's death, Hsiao Chin's lecture in the Red Flag Hall of the Ministry of Culture on 20th century Western art is well attended. This visit is Hsiao Chin's first return to China in 31 years

1981 25th anniversary joint exhibitions of the Ton Fon and Fifth Moon groups, Taipei

1983~1984 Teaches art dissection and painting analysis at the Academia di Belle Arti in Urbino, Italy

1984~1985 Teaches at the Academia di Belle Arti Albertina in Torino, Italy

1985 Begins teaching printmaking at the Academia di Belle Arti di Brera, Milan, where he continues to teach until 1997 as a fully tenured professor

Hsiao is invited by the Chinese government to take part in events celebrating 100th anniversary of the birth of Dr. Sun Yatsen. Travels and exhibits in Brazil

1988 Went to USSR to join in Moscow Exhibition of Italian Contemporary Arts and visited Leningrad

1990 Held Grand 30th Retrospective Exhibition in Marconi Art Gallery of Milano

1991 Thirty-fifth-year anniversary exhibition of Ton Fon and Fifth Moon groups, Taipei, Taiwan

1992	Hsiao Chin Retrospective Exhibition, Taiwan Museum of Art in Taichung, Taiwan
1994	Retrospective exhibitions at Beijing Central Art Academy and Hangzhou Chinese Art Academy, Hsiao's first exhibitions in China
1995	Hsiao Chin: the Odyssey 1953-1994, Taipei Fine Arts Museum
	Hsiao Chin Retrospective Exhibition, Taipei Dimension Endowment of Art; exhibition Catalogue is published by Dimensions Art Center. Marries Austrian soprano Monika Unterberger in May
1996	Teaches at Graduate Institute of Plastic Art in Tainan National University of the Arts since October
1997	A touring exhibition Gathering Force-Beyond the Great Threshold to the New World Series on Hsiao Chin's recent works from 1990 to 1997 organized by the Dimensions Art Center. It goes on to the Galleria IL PONTE in Florence
1998	Schwelleworks of Hsiao Chin" at the Institute Mathildenhoehe Darmstadt in Germany. Exhibition in Shanghai Biennial 1998
2000	7th Venice International Architecture Biannual (Taiwan Pavillion)
	Overseas Collection of Hsiao Chin in Dimension Arts Center
	Held 4 grand retrospect exhibitions in Milano: Marconi Gallery (1958-2001 Painting Work)
2002	Mudima Arts Foundation (2001 Large size new works)
	Studio Lattuada Gallery (Works on paper in previous years)
	Spazio Oberdan of Milan Provincial Government (ceramic works)
	Honored with 6th Arts Award by Taiwan (Culture and Art Foundation)
2003	March to the new world-2003 Hsiao Chin Touring Exhibitionssponsored by Taiwan Culture and Arts Foundation. Feb, Chiao Tung University Arts Center, Hsinchu. Apr, Taiwan Ocean University Arts Center, Keelung. May, ChengKung University Arts Center, Tainan. Sept, Central University Arts Center, Chungli. Oct, CKS Villa, Chungshan University, Kaoshiung. Hsiao Chin Solo Exhibition, Dimensions Arts Center
2004	The Journey of Hsiao Chin's Painting 1958-2004in Shanghai Art Museum
2005	Award Knight title "Star of Solidarity" by Italian president
	Retired from Tainan National University of the Arts, and award as "Emeritus Professor"
	Hsiao Chin's Painting 1954-2004 A Journey back to the sourceat Guangdong Museum of Art in Guanzhou
	Hsiao Chin's Painting 1954-2004 A Journey back to the source, at Zhongshan Museum of Art
2006	Hsiao Chin's Painting 1955-2005, in National Art Museum of China
	siao Chin Solo Exhibition, Lin & Keng Gallery, Taipei, Taiwan
2007	Grand Opening, Lin & Keng Gallery, Beijing, China
	Abstract China, Lin & Keng Gallery, Beijing, China
	Hsiao Chin, TAIYU Beaux Arts Salon, Chiayi City, Taiwan
2008	New Year Exhibition Opening Ceremony – Space B, Lin & Keng Gallery, Taipei, Taiwan
	Homage to the Master: Retrospective of Hsiao Chin, Kaohsiung Museum of Fine Arts, Kaohsiung, Taiwan
2010	The Way is not merely between two points, Lin&Lin Gallery, Taipei, Taiwan
2011	Hsiao Chin 1955-2010 Art Works, Lin & Lin Gallery, Taipei, Taiwan
2012	"Exploring the Wasteland – The Eight Highwaymen of the East" , Da Xiang Art Space, Taichung, Taiwan

蕭明賢

1936	生於台灣南投，現今中興新村
1943	進南投縣營盤國民學校
1949	進草屯初中
1951	作品兩件靜物入選全省美展
1952	受洪敏麟老師的指導和鼓勵，盡心習畫，是年進省立台北師範藝術科〔今國立台北教育大學〕經同學劉芙美和學長蕭勤引薦，從李仲生老師安東街畫室習畫，接受李老師的因材施教著重個性發展的教學，奠定繪畫基礎和思索觀念。
1953	隨李仲生在安東街畫室習畫，夏楊、吳昊、歐陽文苑三人租借空軍總部屬下的防空洞畫畫，週末大家常聚在一起討論繪畫問題，互相觀摩
1954	霍剛和蕭勤同事於景美國小執教，安東街畫友經常前往聚會和郊遊，當時朱為白也加入我們的活動
1955	台北師範學校藝術科畢業
	李老師關閉安東街畫室，遠離台北任教於員林家職，次年轉任彰化女中
	蕭勤赴西班牙經常報導介紹當代國外的繪畫活動，提供外國畫家籍組織畫會宣傳共同的理念。開始嘗試筆墨運行利用棉紙的特性，以鐘鼎文字形作抽象繪畫的元素。
1956	參加全國美展－教育部舉辦。
	和畫友八人創立〔東方畫會〕於台北成員歐陽文苑，吳昊，夏陽，陳道明，李元佳，霍剛，蕭勤，蕭明賢。聯合報專欄作家何凡先生喻稱〔八大響馬〕。
1957	受另藝術(Art Auter)之影響使用自動性寄法表現，具有夢幻般底詩意
	參加巴西聖保羅第四屆雙年展_獲榮譽獎
	首屆東方畫展在台北新聞大樓展出，另有西班牙五位現代畫家參展
	參加西班牙巴塞隆納花園畫廊與台北同時展出
1958	第二屆東方畫展在台北展出
	東方畫展在西班牙克朗畫廊展出 深得好評
	二月在西塞維拉畫廊展出
	十一月在西巴塞隆納維瑞納畫廊展出
	參加亞洲青年藝術家展於日本東京
1959	參加巴西聖保羅第五屆雙年展
	巴黎青年畫家展_教育部選送
	第三屆東方畫展在台北藝術館畫廊展出
	一月在西班牙維芝開那藝術家學會展出_東方畫展
	五月在義大利佛羅倫斯努梅諾畫廊展出_東方畫展
	六月東方畫展在義大利米蘭布魯畫廊展出
	十月東方畫展在義大利佛羅倫斯努梅諾十一畫廊展出
	十一月東方畫展在義大利馬塞拉塔畫廊展出
	入伍服兵役兩年
	繼續運用水墨紙筆作非形像的表現創作
1957~1963	任教位於陽明山之華興育幼院與華興中學
1960	一月參加東方畫展在美國米舟畫廊展出
	東方畫展在義大利美西納畫廊展出
	東方畫展在義大利磊格那諾格垃塔西諾畫廊展出
	參加第一屆香港國際現代藝術沙龍展_獲首獎
	第一次個展在義大利米蘭NUMERO 2
	參加八月東方畫展在義大利威尼斯史蒂法諾畫廊展出
	九月東方畫展在義大利史都戈特聖日那多磊畫廊展出
	十月東方畫展在義大利都林市索拉畫廊展出

十一月第四屆東方畫展和地中海美展，國際抽象畫展聯合在台北市衡陽街新聞大樓展出

參加中國現在畫家展，台北美國新聞處

1961 年底服役期滿，回到華興中學繼續教學

尋找民間藝術與宗廟之美

十二月參加第五屆東方畫展在國立台灣藝術館畫廊展出

1962 十二月參加第六屆東方畫展在國立台灣藝術館畫廊展出

東方畫展在義大利弗拉色替畫廊展出

1963 十二月第七屆東方畫展在國立台灣藝術館畫廊展出

十二月底離開台灣，搭四川輪到香港轉乘法國客運輪越南號道法國巴黎，二月一日上馬賽港正式中法斷交

1964 進巴黎高等美術學院修課

霍剛赴義大利過境巴黎，約夏陽與我接風，三人難得在異域相聚何等歡欣

接未婚妻邱智代到巴黎

十一月第八屆東方畫展在國立台灣藝術館畫廊展出

1965 中國現代藝術家展（義大利羅馬等地）

和邱智代小姐在巴黎結婚

1966 長子Raymond蕭敦出生

1967 次子Roger蕭宇出生

參加西雅圖WDESSNER Gallery主辦現代中國藝術家－東方畫展

借住Isabelle RouanIt〔名畫家Goerges RouanIt的女兒〕在巴黎男郊區的別墅

1968 個展於紐約州中城Green畫廊

參展法國巴黎南郊區國際藝術沙龍

1969 移居美國紐澤西 Middletown

1971 參展Annual Art Festival Sands Point, Long Island 36th. Annual Exhibition is Cooperstown

個展於Empire National Bank Gallery Orange County, NY

個展於紐約州中城Green Gallery Orange County, NY

個展於紐約州Stanford Rexmere Gallery Stanford, NY

1973 移居Ewing, New Jersey

進瓷藝公司Edward Marshall Boehm Porcelain Studio主管設計工作，繼續個人繪畫創作

1996 參加東方畫會和五月畫會現代情，四十週年紀念聯展於高雄積禪五十藝術中心

1997 參加東方畫會和五月畫會現代情，四十週年紀念聯展於台中現代藝術中心和台北、金門等地

1999 參加李仲生師生展，國立台灣美術館主辦，台中，台灣

東方畫會紀念展於上海美術館－東方畫會和決瀾社交換展_台中國美館和上海美術館合辦

2001 從Edward Marshall Boehm Porcelain Studio 退休，前後工作廿七年，多件作品受到國際博物館收藏

2005 參加〔生發與後現代〕－台灣美術〔現代性〕系列展，國立台灣美術館典藏展，台中，台灣

〔現代與後現代〕之間－李仲生與台灣現代藝術，國立台灣美術館典藏展，台中，台灣

2007 作品列於〔藝域長流〕－台灣美術溯源特展，國立台灣美術館，台中，台灣

2012 「藝拓荒原→東方八大響馬」，大象藝術空間館，台中，台灣

獲獎

1957 第四屆巴西聖保羅國際雙年展榮譽獎

1960 第一屆香港國際現代藝術沙龍展首獎

1971 36屆藝術展美國紐約州克泊城藝術展2n Prize

Hsiao Minghsien

Born in Taiwan in 1936, Hsiao Minghsien was a student of Chinese modern painter Mr. Li Chuhshan, one of the founders of the "Ton Fon Art Group". He moved to Paris in 1963 and began two years of studies in the Ecole Nattionale Superieure Des-Beaux-Arts. Part of his works have been presented by Mr. Juan-Edwards Cirlot in his Arts Contemporaneo.

Group Exhibitions

1957-1964 1st to 8th "Ton Fon Art Group" Exhibitions , Taipei, Taiwan

1958 1st Exhibition of Asia's Young Artists ,Tokyo, Japan

1957&1959 4th and 5th Biennale of Saint-Paulo , Brazil

1959 1st Biennale of Young Artist, Paris, France

1960 1st International Modern Arts Salon , Hong Kong

1960-1961 International Exhibition of Maleriei Wolframs-Eschenbach , Germany

1957-1963 "Ton Fon" Exhibition , New York, Italy, Germany, Austria, and various large cities in Spain

1962-1963 Contemporary Chinese Artists Exhibition , Milan, Savana

1963 Exhibition of Chinesische Kunstler der Gegenwart , Museum of Leverkusen, Germany

1967 Contemporary Chinese Art , Seattle, USA

1968&1969 International Arts Salon , Paris South

1971 Annual Art Festival, Sands Point, Long Island, New York, USA

36th Annual Exhibition , Cooperstown, New York, USA

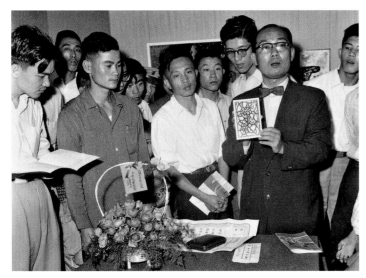

蕭明賢獲獎接受表揚
Hsiao Minghsien was praised for his award

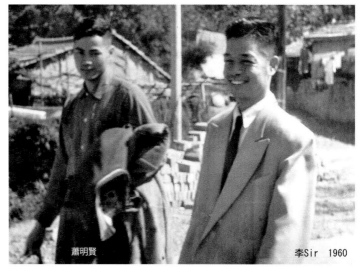

蕭明賢與李仲生, 1960
Hsiao Minghsien and Li Chuhshan in 1960

2012 "Exploring the Wasteland—The Eight Highwaymen of the East", Da Xiang Art Space, Taichung, Taiwan

Solo Exhibitions

1960 Galleria "Numero" 2 , Florence, Italy

1968 Green Gallery (Middletown, New York

1971 Empire National Bank Offices , Orange County, New York

Rexmere Gallery , Stamford, New York

Awards

Honorable Prize of the 4th Biennale Saint-Paulo (Brazil, 1957)

Golden Prize of the 1st International Modern Arts Salon (Hong Kong, 1960)

2nd Prize of the 36th Annual Cooperstown Art Association Exhbition (Cooperstown, New York, 1971)

Works Kept By:

Museum of Modern Art in Barcelona, Spain

Museum of Contemporary Art in Skoplje, Yugoslavia

Museum of History in Taipei, Taiwan

Taiwan Museum of Art

感謝誌

本展承蒙藝術家、藝術家朋友、收藏家們慷慨提供豐富的作品及文件資料，使展覽得以順利
完成，本館謹向下列個人致上誠摯的謝意。

王飛雄　先生

朱為白　先生

林學熙　先生

孫　巍　先生

陳明仁　先生

Acknowledgements

We are grateful to the Artist , Artist's friend and the collectors whose generous for their kind support to this exhibition.

Mr. Wang Fei- hsiung

Mr. Chu Weu-bor

Mr. Lin Shieh-shi

Mr. Franco Sun

Mr. Chen Ming-jen

國家圖書館出版品預行編目(CIP)資料

藝拓荒原 : 東方八大響馬 / 鍾經新主編.
－第一版. -- 臺中市 : 大象藝術空間, 2012.06
136面;28.5x28.5公分
ISBN 978-986-88128-3-3
1.繪畫 2.畫冊

947.5 101009620

2012.6.20~7.20

藝拓荒原→東方八大響馬

Exploring the Wasteland – The Eight Highwaymen of the East

發 行 人：鍾經新
主　　編：鍾經新
責任編輯：蘇新媚
裝幀設計：蘇新媚
英文翻譯：Brent Heinrich、胡琦君
英文校對：陳思蓉、詹春瑩、姚宏儒
中文校對：陳思蓉、詹春瑩、姚宏儒
出版發行：大象藝術空間有限公司
地　　址：404台灣台中市北區博館路15號
電　　話：886-4-22084288
傳　　真：886-4-22083188
網　　址：www.daxiang.com.tw
信　　箱：daxiang.art@msa.hinet.net
印刷製版：興台彩色印刷股份有限公司
紙張提供：東玖企業有限公司
開　　本：285mm×285mm
版　　次：2012年6月第一版
　　　　　2012年6月第一次印刷
書　　號：978-986-88128-3-3
定　　價：NT.880元整

劃撥帳號：22549088
戶　　名：鍾經新

ISBN978-986-88128-3-3
9 789868 812833